MW01007111

50 Shades of V

By
The Artist
JEGAL

50 Shades of V

Published January 2021 by Purple Whale Publishing

50 SHADES OF V by The Artist JEGAL
ISBN 978-1-7336246-9-5
Nonfiction

Printed in the USA

The Artist
JEGAL

Table of Contents

An Interview with The Artist JEGAL

QUESTION: **Please give an overview of how this idea came to you and how it's taken you a dozen years or more to accumulate these sketch images that you've done. Just a little history lesson from you—how it all came together?**

Artist JEGAL: The Vulva Project! Vulva Art in representation of each state. Ahh—this started a long time ago and evolved over time. The idea came to my mind from talking to other people. I remember a long time ago hearing the expression "you are a pussy." And I said to myself—"Wow! Why did he call him that?" It makes no sense to me. The Vulva has power and elegance and it's very strong and the vulva is beautiful and can give such great pleasure. I could go on and on about the secret of sacred femininity. Why do the females possess such influence and persuasive power? Because a woman is the art of life.

And there was another general comment I've heard uttered many times, something to the effect of "you know, vaginas are ugly." This statement blows my mind. Well, you use it and you kiss it—how can it be ugly? So, a lot of things came to my mind. As an artist and a lover and fan of females—I was perplexed. It is my goal to present a vagina, or vulva, in a way that really is not ugly, but is very pretty. A vulva is strong and divine—a life-giving, birthing creator. A vulva is majestic. The vulva does a great job! I have sincere appreciation for the power of the vulva. So, these thoughts came to me and I started an artistic project to present my drawings. The point is to NOT be pornographic, but realistic. Realistic enough to admire the beauty, the power, the grace, the sacred divinity of the vulva. Once and for all, the power of taking on the female body and you know—study it and treat it like the highest creation of art, which it is. But these pornographic images treat it as dirty and create a hypocrisy in society. My goal or aim is to make the vulva presentable at an elevated level as the purest of art. I took on this project with this focused mindset.

QUESTION: **You were not deterred with having your work labeled as "dirty" art or "erotic" art?**

Artist JEGAL: The Vulva is generally a taboo subject. Why don't we treat the subject with the proper respect it deserves? Women are wonderful. Women are the light of the world. I would like to present my own differing point of view of the vulva. The vulva is the star in this experience of human life. I will bring notice to the females in the sacred feminine mystique by focusing on the art, and not making it a pornographic thing. But elevating it to a high-level type of deal. Well then, if you see all the drawings, it speaks for itself very realistically. It is the idea to make a vulva on a woman look like a lady, a lady's vulva. "This is a beautiful vagina—a pure work of living art!"

QUESTION: **"50 Shades of V"—how did you come up with that expression? What does it mean?**

Artist JEGAL: My title name is because my sketches are shades of black and white and the stand-alone "V" is mysterious. And, the title is a takeoff of the recent book series best seller, *Fifty Shades of Grey.*

I refined the basis of my art project by making the decision that I would sketch a vulva in all 50 states as well as a "bonus" representing the national capital in D.C. It took me over a dozen years to complete. I've asked thousands of women for the pleasure to sketch their vulva. The majority of the time they politely decline, but every now and then a conquest occurs and I have the opportunity to sketch a fresh lively vulva, nature's purest art form.

QUESTION: One of the things about this whole project that is fascinating is you talking these women, one by one, into doing this. I mean you've got to be a suave and debonair guy. You've got to have a line of bullshit that's a mile long to get a woman to— "Oh yeah, I will spread my legs and show you my vagina so you can draw me." How much of a challenge was that for you to pull off?

Artist JEGAL: I never saw it as a challenge. I never saw this as a challenge because broadly, generally, I like people, I like to talk. I like to talk to people all the time. I enjoy socializing. I don't care if I know them or not. I find people to be very interesting. I just go on and introduce myself. And it's a natural thing for me doing that. I'm always very friendly and nice. I think to myself, what can she say? "No!"

In reality when you are going to approach a woman to ask to see her vulva for the sake of art—her vulva—your goal is to me, to get this lady to pose for you. So do not approach her with this line, "Can I see your vagina?" because it will not work. You have to have a plan. I always have a plan. The best way is to make the woman comfortable and accountable with you, and how do I do that? By being accountable myself to her by offering my friendship and being honest and sincere about my artwork. When a woman knows you are sincere and genuine in your efforts for the sake of the art and not as a come-on for sex, then she can be very willing to pose her vulva for me.

None of them refuse in a bad way because they say a line like, "I got a boyfriend and I cannot do it." It's stuff like that, but not with violence. Again, it depends on how you are with people. I think that helps.

QUESTION: Do you explain your art and philosophy when recruiting a poser?

Artist JEGAL: Absolutely. In the beginning you have to talk like a regular person, sometimes as just a normal guy, you are picking up on them for sex and they like that but you want something else with them. It is a friendship. Be happy. Be fun and be lively. You are there to conquer a woman. But in reality, you just have your goal that is to see if she will let you draw her vulva. Sometimes it can take a long time. Sometimes it takes me a month to find someone willing.

QUESTION: **You have never said in any of these situations, that you ever turn them into sexual situations? You kept it totally on the artistic line all the way through?**

Artist JEGAL: Yes. Yes. Although there were a few times where it seemed to happen, but you know this zipper. I keep it zipped. The art is what really matters. I have such passion for this art project. Out of 100 women that I approach, they say "no." Then, only, probably, one percent or one out of every 100 say "Yes." Oh yeah, I'd say that's why it took so long because it's a hard thing to accomplish. Because it is so difficult to get a willing vulva poser, I never let sex get in the way. Very disciplined.

QUESTION: **How hard was it to find a vulva poser in all 50 States?**

Artist JEGAL: I think the magic word for the ones who do it is they want to be part of the project. They want to be part of the art. They feel honored to participate. Getting the last dozen states or so to complete the project was a bit of a challenge. I networked with other artists, traveled around, hung out at airports talking to women. I got Alaska, Wyoming, Idaho, Nebraska, and Kentucky from friends who know friends who were willing to pose.

QUESTION: **You ever have a woman slap you or go get her boyfriend or husband after you?**

Artist JEGAL: No, no, no. Because that is precisely to be avoided. I am not disposed to violence and rough stuff. I never say what I want regarding sex, just the ART. All for the art!

QUESTION: **How did "Anonymous" help you in persuading vulva posers?**

Artist JEGAL: I'm right up front about hidden identity, the anonymous tag, and even though I don't use their names, I never even care about their names so they can feel more comfortable being anonymous. I've observed that my willing participants really feel like they want to be part of the artwork in some way and I guess this is a good thing. I could've gone to art schools, clubs of, let's say you know, topless clubs, and find that kind of willing people. But I want to do my art project with real people, with people that do not have anything to do with overt sexuality like with strip joints and pornography. I didn't want to go to a temple or go to a club and get one of those topless dancers drawn and then put her in the car with her legs up and then ride around out in the alley and drive while she poses her crotch. No, no. I will not do that. That action alone will debase my art. The vulva should be treated and revered as a priceless treasure at all times. In my mind anyways . . .

I've tried to teach everyday people, regular people about these kinds of art projects and discovered that this practice is very hard to do with a good laugh with most people because they are not into my way of art. If you talk to them about country music or the baseball game or, you know, the football game—I'm pretty sure they would do anything for a couple tickets, but, you know, when you talk about art— what is that? "You crazy man?" They say it's like ten percent of the population really care about ART. The other 90% don't really care what an artist conceives.

I decided to do my vulva art project with regular women, with a regular everyday woman, with women I may see at Walmart or a corner store and suddenly that day to see if they want, if I can move inside their mind and heart, and if they want to be part of something special like this. When they agree to do it, when the book comes out and one of them, who knows, whatever, when she gets a copy of the book, I know she is going to have a big smile when she sees her little vulva on the page. And even though I'm not going to be with her, I know this is going to happen and that does give me great satisfaction. It gives me a beautiful energy knowing that person is in the know, with the big secret! "This is my vagina!" or, "This is my vulva!"

QUESTION: Another decision that you made on this project is you're mainly a painter, but you decided you were not going to paint these vulvas on this project, but instead you use sketches.

Artist JEGAL: Yeah, I decided that I want to do it in black and white. And the reason is because if I use color it's not going to be more attractive to her. Black-and-white is classic. Black and white for certain reasons has this classiness. When you see a photograph, a black-and-white photograph, it may have an impact on your mind, settle in your brain, with a longer-lasting impact. It has a certain amount of prestige or class. So that is why I decided not to do it as paintings but black-and-white drawings. Another reason is because it's a very fast, very easy method. Where, conversely, if she'd done a painting pose the person would probably have to go through at least three separate sittings and each one of them two hours or so. Drawing or sketching is much faster than doing a painting. Plus being mobile with the convenience to carry my material because I just use paper and pencils and it's easy to be ready at any time by carrying your materials with you in your backpack or whatever you have at the moment and that's why I elected to do it as drawings instead of paintings.

QUESTION: Do you have a count of how many vulvas you've sketched?

Artist JEGAL: Yeah, like 62 vulvas I've submitted for this book. I've actually done over 300 vulva sketches worldwide. But you must remember that I went through thousands of noes to find the willing vulva posers. And I still want to do some other ones for the next project, so I'm always looking for the next opportunity.

50 Shades of V

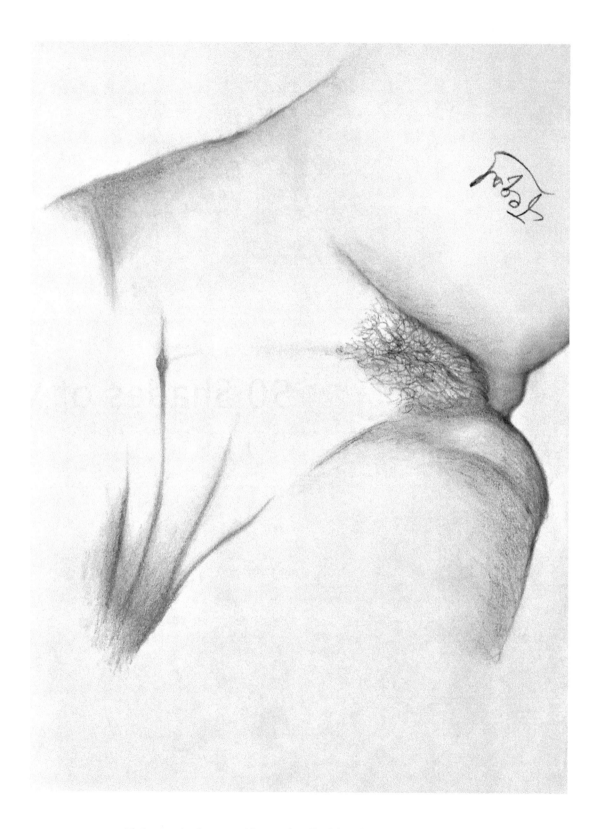

Alabama is fine art. I'm enthralled by the amazing sacred feminine vulva. — *Artist JEGAL*

Sacred Feminine Vulva of Alabama

Alabama is the State in the Heart of Dixie.

The great state of Alabama joined the union in 1819 as the 22nd State.

Alabama comprises over 51,000 square miles of America.

Home to the NASA Space Flight Center in Huntsville, and the birthplace of Helen Keller not far from Wheeler Dam in the North.

The Yellowhammer bird flies to a branch on a Longleaf Pine tree, and a Camellia flower blooms below—all state symbols to glorify the uniqueness of Alabama.

Deep in the heart of Dixie spread throughout the region from Montgomery to Mobile Bay to Birmingham to Selma to Tuscaloosa as well as all points in between the Alabama landscape—permeate the great sacred feminine energies . . .

<p align="center">~⌣~</p>

Sacred Feminine Vulva of Alabama

<p align="center">Southern delight</p>

<p align="center">Energy bright</p>

<p align="center">Feminine persuasion</p>

<p align="center">Positive elation</p>

<p align="center">Electromagnetic</p>

<p align="center">Mystique</p>

<p align="center">Quite unique</p>

<p align="center">Women of Dixie</p>

<p align="center">Pride and joy of the south</p>

<p align="center">Sacred Feminine of Alabama</p>

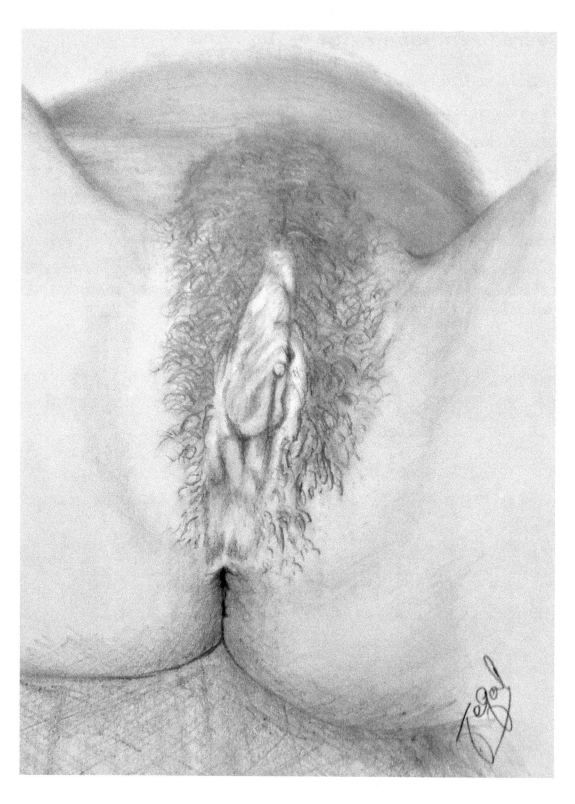

Alaska is warm, cozy and furry. What a joy to find my poser from the far winter land. Just breathtakingly beautiful. — Artist JEGAL

Sacred Feminine Vulva of Alaska

Alaska is the Land of the Midnight Sun.

Alaska joined the Union as the 49th State in 1959. The largest state, exceeding over 596,000 square miles. Alaska has over three million lakes and many unexplored tracts of wilderness, glaciers, volcanoes, and extensive mountain ranges.

Alaska is the only U.S. territory that once belonged to Russia; only 55 miles separate the countries at the Bering Strait. In 1896 gold was discovered in the Klondike region.

Mount McKinley is the highest point in North America.

The Willow Ptarmigan bird flies to a branch on a Sitka Spruce tree, and a Forget-me-not flower blooms below the canopy, all state symbols to glorify the uniqueness of Alaska.

From the Arctic Circle to the North into the edge of northeastern Yukon Territory to Anchorage to Fairbanks to Nome to Sitka to Juneau, from the Inside Passage to the Bering Strait, as well as all points in between the Alaska landscape—permeate the great sacred feminine energies . . .

Sacred Feminine Vulva of Alaska

Winter wonderland

Vast wilderness

Transcendent

Mystical

Womanhood

Blooming

Life giver

Mother, sister, daughter, wife

Loving life

Sacred Feminine of Alaska

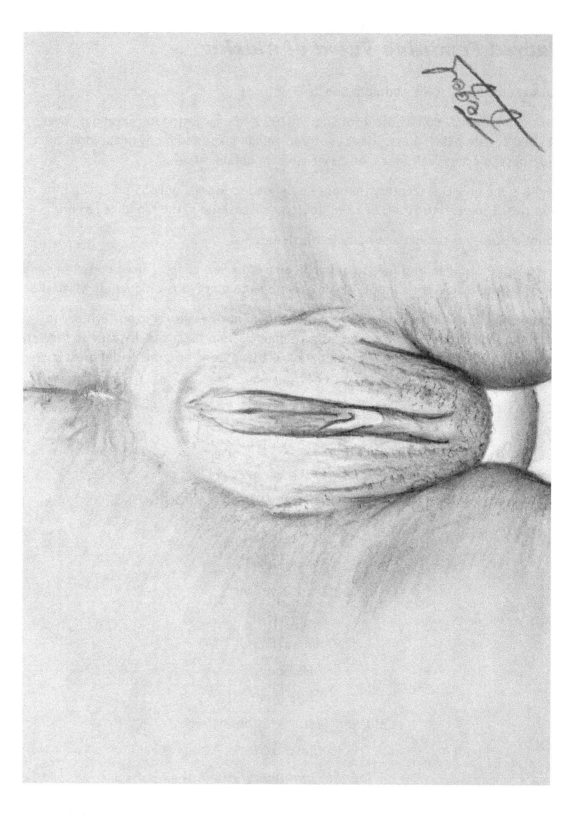

Arizona women are great. The sacred feminine is sparkling everywhere in the southwest. Those curves, mother nature's design, such softness. — Artist JEGAL

Sacred Feminine Vulva of Arizona

The Grand Canyon State joined the Union as the 48th State in 1912.

Arizona has the largest Indian population of any state with 13 tribes. The main tribes are the Navajo, Hopi, Apache, Papago, and Pima.

The Grand Canyon is a mile deep and over 200 miles long.

Arizona is home to Major Meteor Crater. Other geologic marvels from prehistoric peoples are the Painted Desert and the Petrified Forest.

The Cactus Wren flies to a branch on a Paloverde tree, and a Saguaro flower blooms below the canopy, all state symbols to glorify the uniqueness of Arizona.

From Phoenix to Tucson to Tempe to Yuma to Flagstaff to Lake Mead and Hoover Dam, as well as all points in between the Arizona landscape—permeate the great sacred feminine energies . . .

Sacred Feminine Vulva of Arizona

Southwest femininity

Mystical quality

Magical mystery

Womanhood

Sacred elite

Powerful

Magnetic

Transcendent

Sweet sensation, fascination

Sacred Feminine of Arizona

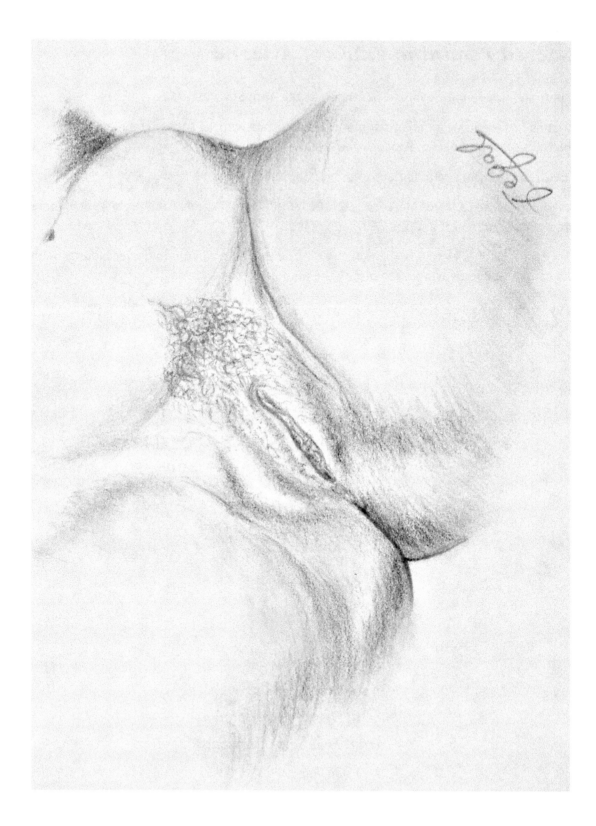

Arkansas is a joy to sketch. I am honored to behold something so enchanting and provocative. — *Artist JEGAL*

Sacred Feminine Vulva of Arkansas

Arkansas, the Land of Opportunity, joined the Union in 1836 as the 25th State. Arkansas encompasses over 53,000 square miles.

Arkansas has the only diamond mine in North America. 95% of the aluminum ore produced in the U.S. comes from a town named Bauxite.

Arkansas is known for the Ozark National Forests and exceptional natural springs.

The Mockingbird flies to a high branch on a Pine Tree, and an Apple Blossom blooms below—all state symbols to glorify the uniqueness of Arkansas.

From Little Rock to Pine Bluff to Hot Springs to Murfreesboro as well as all points in between the Arkansas landscape—permeate the great sacred feminine energies . . .

Sacred Feminine Vulva of Arkansas

Femininity supreme

Essential

Magnetic

Powerful

Womanhood blooming

Inspirational

Force of creation

Producing

Selfless compassion and empathy

Sacred Feminine of Arkansas

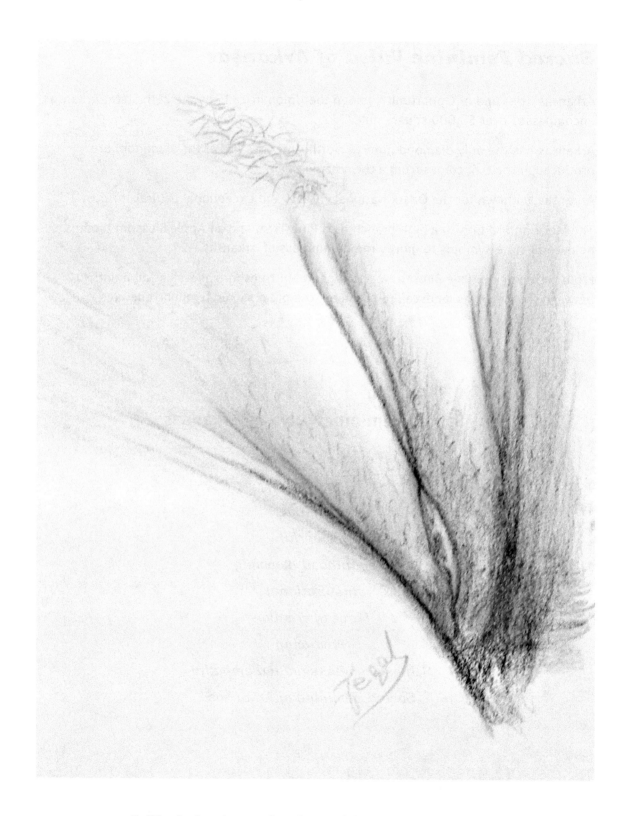

California females are fun. So much beauty for me to sketch.
Universal vibrations of cosmic femininity. — *Artist JEGAL*

Sacred Feminine Vulva of California

The Golden State joined the Union as the 31st State in 1850, shortly after the 1849 Gold Rush. California is now the most populous state.

California comprises over 158,000 square miles.

Death Valley is the lowest point in the U.S. at 282 feet below sea level.

California houses the largest reflector telescope at Mount Palomar.

The Valley Quail flies to a branch on a giant Redwood tree, and a California Poppy flower blooms below the canopy—all state symbols to glorify the uniqueness of California.

From San Francisco to San Diego to Los Angeles to Sacramento to Fresno to Lake Tahoe to Santa Barbara to Anaheim and from Disneyland to Hollywood to the Golden Gate Bridge to Yosemite National Park as well as all points in between the California landscape—permeate the great sacred feminine energies . . .

———⌣———

Sacred Feminine Vulva of California

Magical and mystical

Exceptional

Womanhood

Blooming flower

Enveloping

Absorbing

Enwrapped with loving kindness

Gentle vibrations

Harmonious and harmonic

Sacred Feminine of California

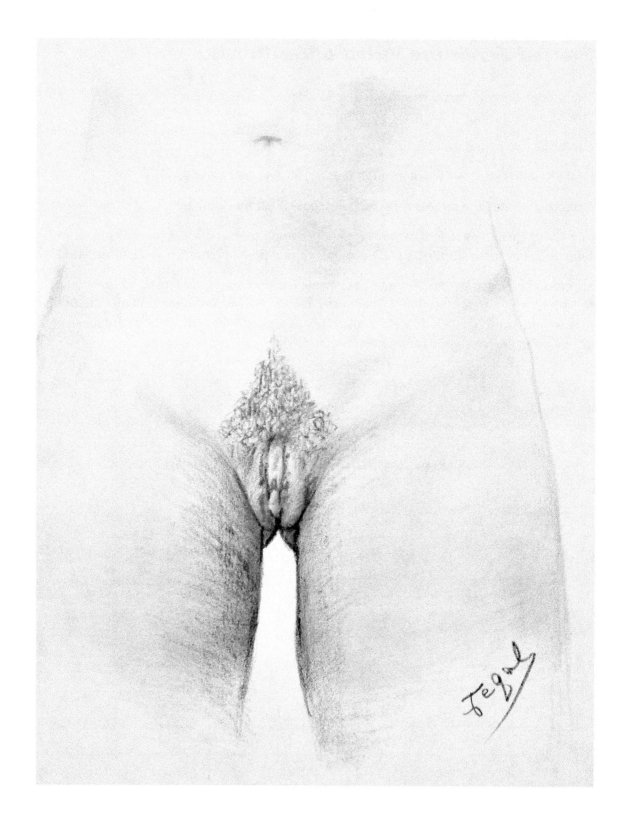

Colorado women are free spirits. What elegant art for my eyes to absorb. Pure natural art. — *Artist JEGAL*

Sacred Feminine Vulva of Colorado

Colorado is the Centennial State, having joined the USA as the 38th State in 1876.

Colorado is the highest state in the Union, encompassing part of the Continental Divide, over 104,000 square miles and a mile high. Within its borders are 54 of the nation's highest mountains—the range of peaks that separates the rivers that flow east and west.

The Native Indians are Pueblo, Ute, Arapahoe, and Cheyenne.

Home to Rocky Mountain National Park and Mesa Verde National Park, as well as North American Air Defense Command (NORAD), National Center for Atmospheric Research, and seven Atomic Energy Commission installations.

The Lark Bunting flies to a branch on a Colorado Blue Spruce tree, and a Columbine flower blooms below the canopy—all state symbols to glorify the uniqueness of Colorado.

From Denver to Boulder to Aspen to Colorado Springs as well as all points in between the Colorado landscape—permeate the great sacred feminine energies . . .

―――⌣―――

Sacred Feminine Vulva of Colorado

Rocky Mountain High

Electromagnetic

Transcendent

Great womanhood

Endless inspirations

Connecting vibrations

The lure of love

From below and above

Inside, outside, all over

Sacred Feminine of Colorado

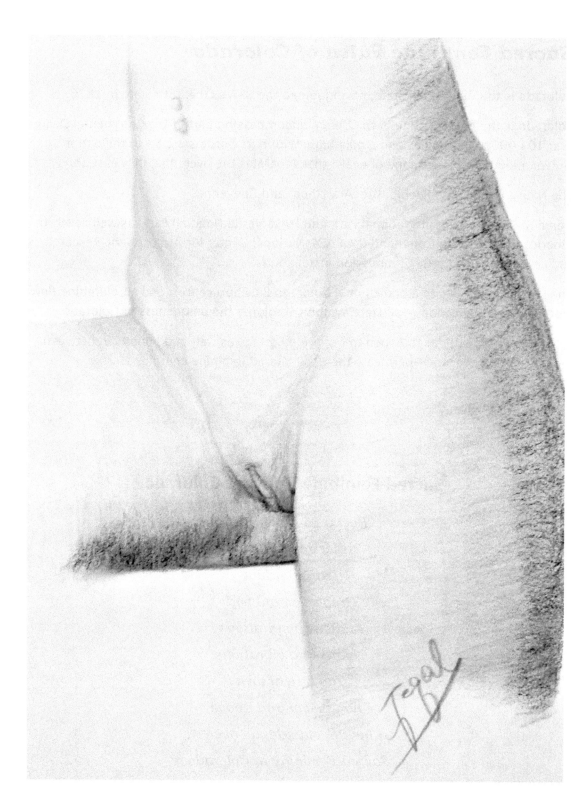

Connecticut is absolute perfection. Astounding geometry! What a poser. — Artist JEGAL

Sacred Feminine Vulva of Connecticut

The great state of Connecticut was admitted to the Union in 1788 as the fifth State, one of the original 13 colonies. The Constitution State is over 5,000 square miles.

From Yale college founded in 1704 to Noah Webster publishing the first American dictionary to Charles Goodyear inventing vulcanized rubber—Connecticut is on the front lines of advanced education and technological revolution.

The American Robin flies to a branch on a White Oak tree, and a Mountain Laurel flower blooms below the canopy, all state symbols to glorify the uniqueness of Connecticut.

From Hartford to New Haven to Stamford to Mystic to Waterbury to Norwich as well as all points in between the Connecticut landscape—permeate the great sacred feminine energies . . .

Sacred Feminine Vulva of Connecticut

Transcendent and inspirational

Phenomenal vibrations of electric energies

Sparking creativity

Leading and influencing

Promoting goodwill

Sisterhood, womanhood

Daughter, mother

Lover

Friend

Sacred Feminine of Connecticut

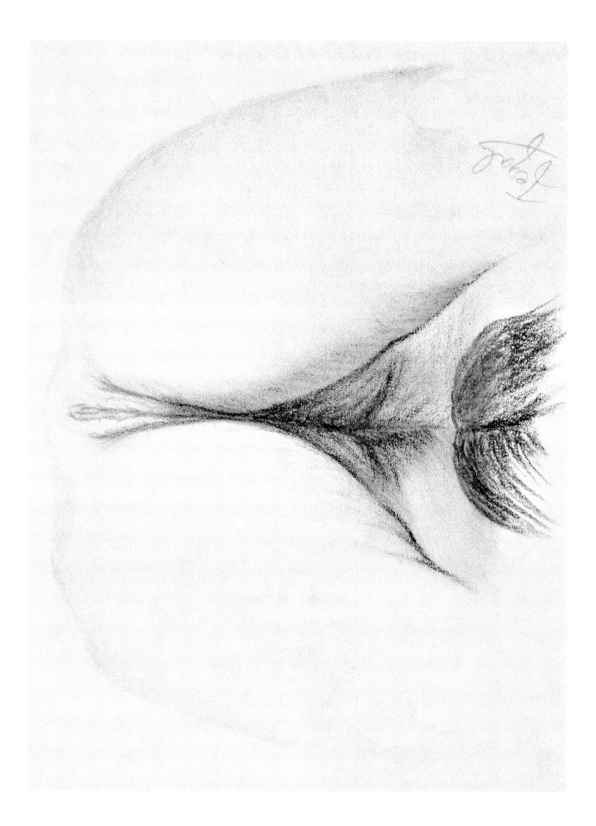

Delaware resembles royalty to me. Benevolent.
Powerful. — Artist JEGAL

Sacred Feminine Vulva of Delaware

Delaware is the First State. On December 7, 1787 Delaware became the first State to ratify the new Federal Constitution and the only state whose territory once belonged to Sweden and Holland.

Delaware is just over 2,000 square miles.

The Blue Hen Chicken flies to a branch on an American Holly tree, and a Peach Blossom flower blooms below the canopy—all state symbols to glorify the uniqueness of Delaware.

From the Chesapeake and Delaware Canal to Dover to Wilmington to New Castle to Rehoboth to Delaware Bay, as well as all points in between the Delaware landscape—permeate the great sacred feminine energies . . .

Sacred Feminine Vulva of Delaware

Womanhood magnificence

Harvesting enchantment

Spreading love

Generating unique Delaware vibes

Tribes of female persuasion

Relating sensations

Of momentary bliss

With long-lasting effects

Transcendent wonders

Sacred Feminine of Delaware

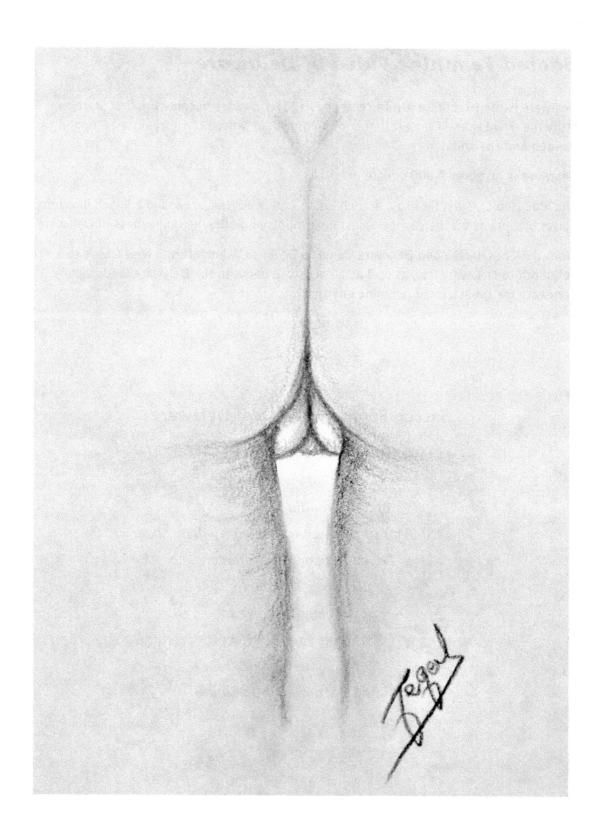

Florida is artistic and sensual. Magnificent views. I enjoyed sketching this lovely vulva very much. — Artist JEGAL

Sacred Feminine Vulva of Florida

Florida, the Sunshine State, joined the Union as the 27th State in 1845.

Florida comprises over 58,000 square miles and over 4,000 miles of coastline.

The Northern Mockingbird flies to a branch on a Sabal Palm tree, and an Orange Blossom flower blooms below—all state symbols to glorify the uniqueness of Florida.

From Miami to Orlando to Tampa Bay to Jacksonville to Tallahassee to Daytona Beach to Fort Lauderdale and from Cape Kennedy to Disney World to Everglades National Park as well as all points in between the Florida landscape—permeate the great sacred feminine energies . . .

<p style="text-align:center">⌣</p>

Sacred Feminine Vulva of Florida

<p style="text-align:center">
Sunshine and water

Harmony and blessing

Stunning

Exceptional

Womanhood

Intuitive energy

Comforting kindness

Perfecting poise

Life is joy

Sacred Feminine of Florida
</p>

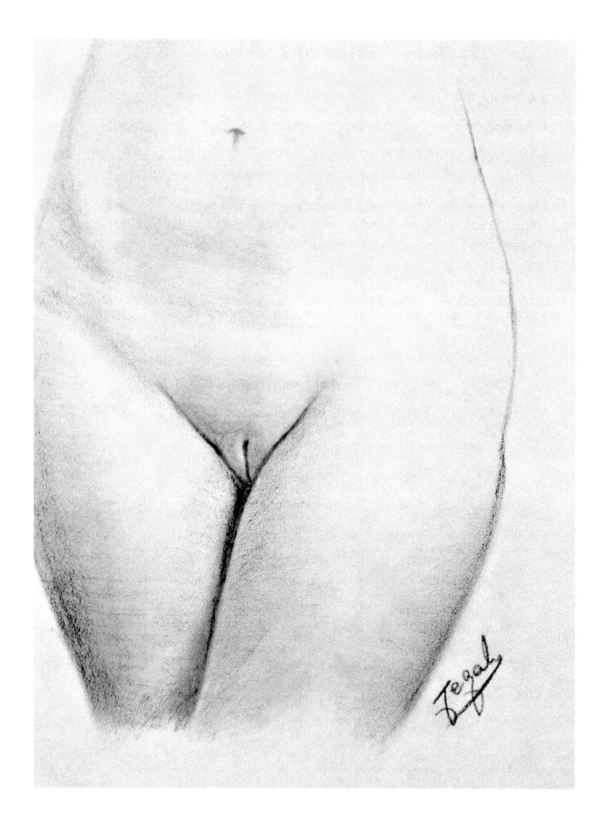

Georgia women are represented by a fantastic liberated poser.
Such fine proportions and elegant form. — Artist JEGAL

Sacred Feminine Vulva of Georgia

The Peach State is the largest state east of the Mississippi River. Georgia covers approximately 59,000 square miles.

Georgia was the last of the 13 colonies established by England. In 1788 Georgia became the fourth State to ratify the Constitution and join the Union.

In 1793 Eli Whitney invented the cotton gin at a plantation near Savannah.

In 1838 the entire Cherokee nation was removed from the state.

The Brown Thrasher bird flies to a branch on a live Oak Tree, and a Cherokee Rose flower blooms below the canopy—all state symbols to glorify the uniqueness of Georgia.

From Atlanta to Macon to Augusta to Athens to Savannah as well as all points in between the Georgia landscape—permeate the great sacred feminine energies . . .

———⌣———

Sacred Feminine Vulva of Georgia

Southern Belle

Polite and charming

Sincere enthusiasms

Fun loving

Harmonious energies

Influencing, guiding, leading

Developments in goodwill

Sensitive focus

Progressive wisdom

Sacred Feminine of Georgia

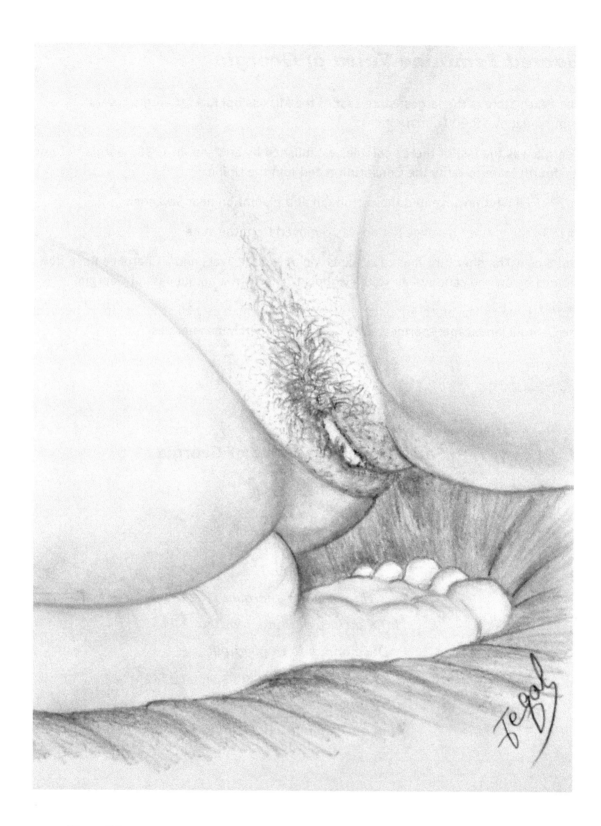

Hawaii is exotic. Looking out at the glorious power emanating from the vulva sketch, just takes my breath away and astonishes me. — *Artist JEGAL*

Sacred Feminine Vulva of Hawaii

The Aloha State joined the Union as the 50th State in 1959. The nation's only island state, a group of 20 islands with six principal ones, extending over 375 miles. Located in the Pacific about 2,400 miles from California.

Hawaii comprises over 6,400 square miles.

December 7, 1941 – the Japanese attacked Pearl Harbor.

The Hawaiian Goose flies to a branch on a Kukui tree, and a Hibiscus flower blooms below the canopy, all state symbols to glorify the uniqueness of Hawaii.

From Oahu to Kuai to Maui to Molokai to Honolulu to Waikiki Beach to Diamond Head as well as all points in between the Hawaiian landscape—permeate the great sacred feminine energies . . .

Sacred Feminine Vulva of Hawaii

Mysterious island wonders

Hula girl

Paradise

Sweet, friendly and nice

Enraptured

Alluringly seductive

Magnetic

Tranquil

Serene

Sacred Feminine of Hawaii

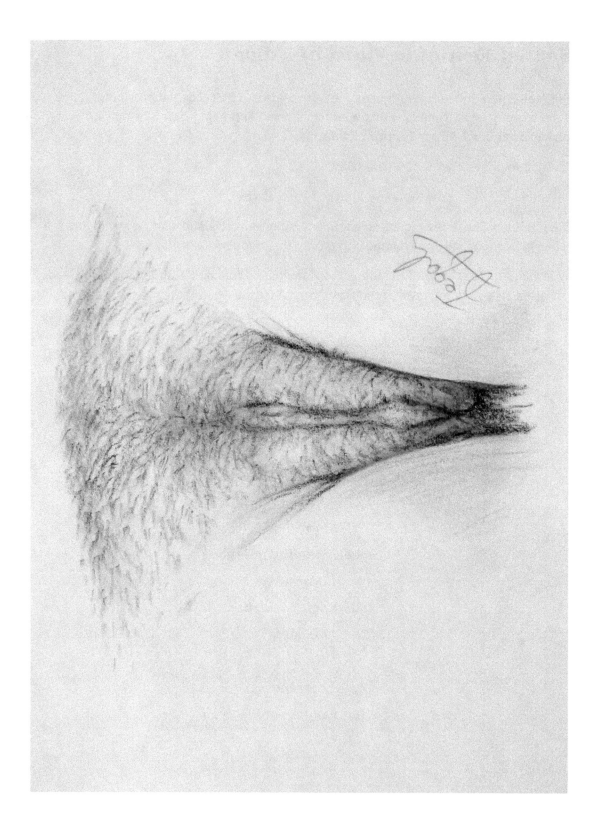

Idaho is alluring and sensual and lovely to behold. What a masterpiece work of art. Exquisite! — *Artist JEGAL*

Sacred Feminine Vulva of Idaho

The Gem State joined the Union as the 43rd State in 1890. Idaho comprises over 83,000 square miles—dramatic waterfalls, rugged mountains, barren lava fields, large lakes, and deep gorges.

More lead and silver are produced in Idaho than in any other state.

Idaho is home to Craters of the Moon National Monument.

Several Indian Tribes live on State reservations—Nez Percé, Shoshone, Paiute, Kootenai, Couer d'Alene.

The Mountain Bluebird flies to a branch on a Western White Pine tree, and a Lewis Mock Orange flower blooms below the canopy, all state symbols to glorify the uniqueness of Idaho.

From Shoshone Falls to Hells Canyon to Sun Valley to Boise as well as all points in between the Idaho landscape—permeate the great sacred feminine energies . . .

Sacred Feminine Vulva of Idaho

Natural nature

Fun character

To her, life is a gift—each day a present

Alluring

Free spirit

Fascinating

Sensational

Questing

Sparking constant joys

Sacred Feminine of Idaho

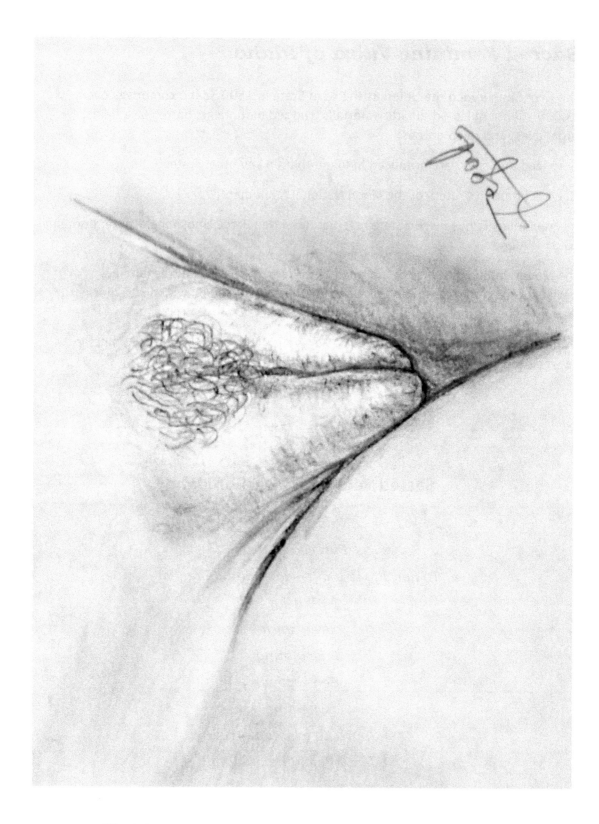

*Illinois is magnetically attractive. Pure essence of natural beauty.
I enjoyed creating this sketch.* — *Artist JEGAL*

Sacred Feminine Vulva of Illinois

The Prairie State joined the Union as the 21st State in 1818. Illinois encompasses over 56,000 square miles—almost 90% of the land is used for farming.

Illinois is the "Land of Lincoln"—home and tomb.

The Northern Cardinal flies to a branch on a White Oak tree, and a Native Violet flower blooms below the canopy, all state symbols to glorify the uniqueness of Illinois.

From Chicago to Peoria to Springfield to Urbana to Joliet to Rockford to East St. Louis as well as all points in between the Illinois landscape—permeate the great sacred feminine energies . . .

~

Sacred Feminine Vulva of Illinois

Midwest heartland

Loving bond

Womanhood

Celebration

Justification

Liberation

Integrity and trust

Must go a long way

For quality femininity is here to stay

Sacred Feminine of Illinois

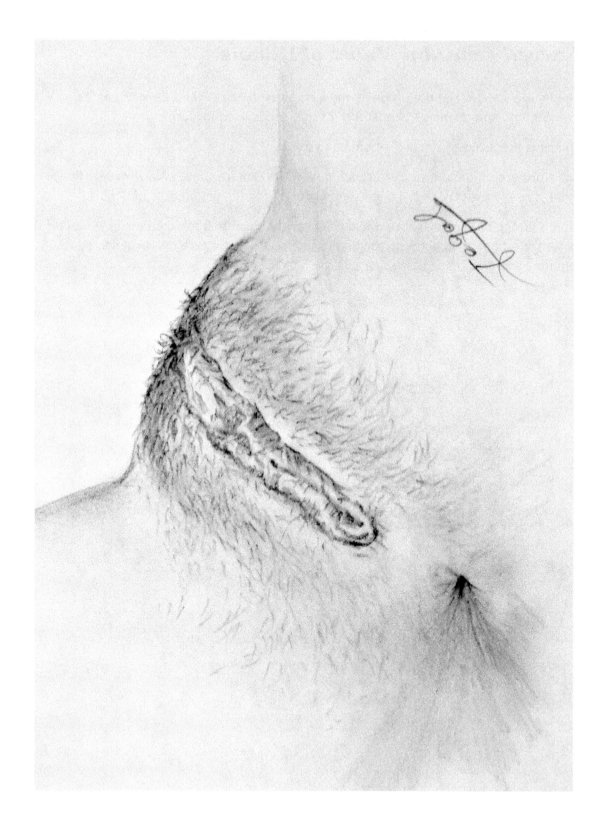

Indiana is heartwarming, all-American. Such positive energy.
What a vulva sketch! — Artist JEGAL

Sacred Feminine Vulva of Indiana

The Hoosier State joined the Union as the 19th State in 1816. Indiana encompasses over 36,000 square miles.

Indiana is home to the annual national event of the Indianapolis 500 race on Memorial Day Weekend.

The Cardinal flies to a branch on a Tulip tree, and a Peony flower blooms below the canopy, all state symbols to glorify the uniqueness of Indiana.

From Indianapolis to South Bend to Fort Wayne to Gary to Terre Haute to Evansville as well as all points in between the Indiana landscape—permeate the great sacred feminine energies . . .

Sacred Feminine Vulva of Indiana

Soft and gentle

Firm intuition

Influencing love

Guiding emotions

Paving the way

Female power vortex

Essential

Enlightening

Inspiring

Sacred Feminine of Indiana

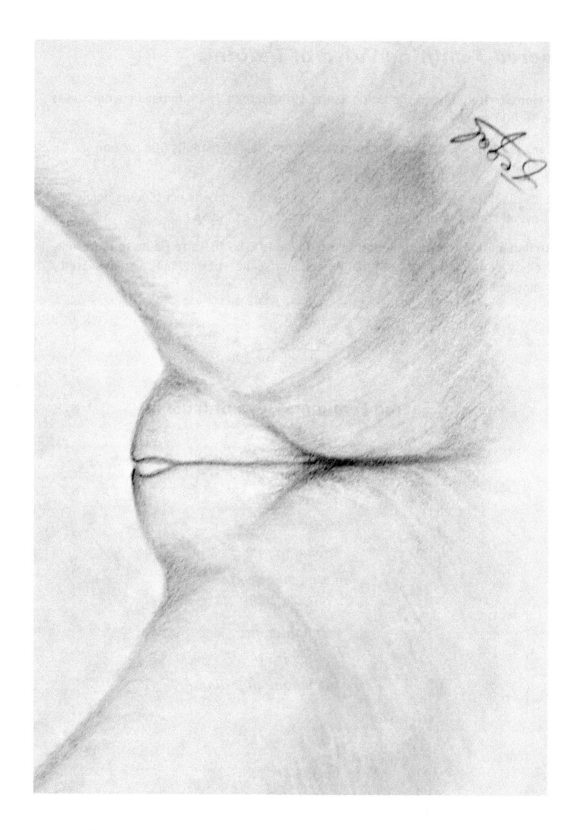

Iowa women are represented by a gorgeous poser. Fine art at its finest. I'm in awe! — Artist JEGAL

Sacred Feminine Vulva of Iowa

The Hawkeye State joined the Union as the 29th State in 1846. Iowa encompasses over 56,000 square miles.

In Iowa 97% of the land is cultivated for farm use. There are well over 100,000 farms; in some years Iowa supplies 10% of the entire country's food.

The Eastern Goldfinch flies to a branch on a Bur Oak tree, and a Prairie Rose blooms below the canopy, all state symbols to glorify the uniqueness of Iowa.

From Des Moines to Cedar Rapids to Davenport to Iowa City to Council Bluffs to Sioux City as well as all points in between the Iowa landscape—permeate the great sacred feminine energies . . .

Sacred Feminine Vulva of Iowa

Farmland heartland

Women to celebrate

Great joys, laughter and fun

Harmony

Friendship

Compassion

Empathy

Trust and loyalty

Dependability

Sacred Feminine of Iowa

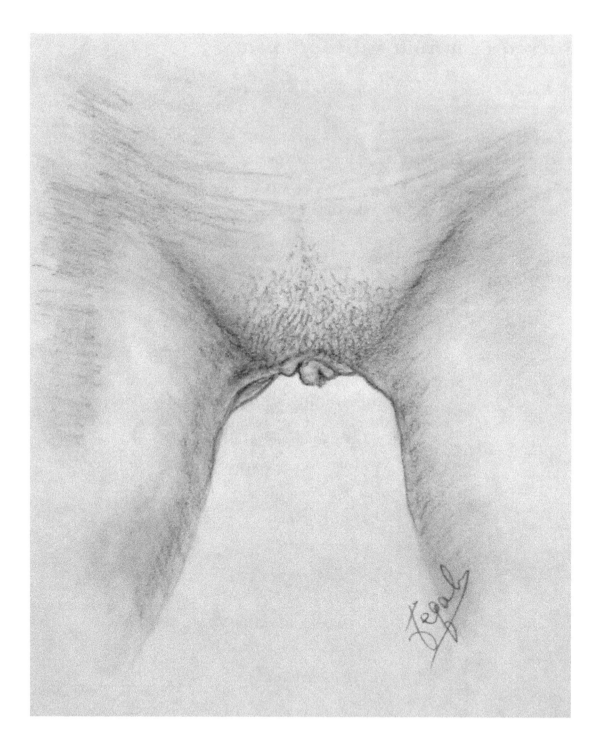

Kansas women from the sunflower state are exceptional. My anonymous poser did it right. — Artist JEGAL

Sacred Feminine Vulva of Kansas

The Sunflower State joined the Union as the 34th State in 1861. Kansas is positioned at the geographic center of the 48 contiguous states.

Kansas encompasses over 82,000 square miles. The pioneering Santa Fe Trail goes through Kansas.

Kansas is home to several Indian Tribes: Kansa, Osage, Pawnee, Comanche, and Apache.

The Western Meadowlark flies to a branch on a Cottonwood tree, and a bright yellow Sunflower blooms below the canopy, all state symbols to glorify the uniqueness of Kansas.

From Wichita to Topeka to Abilene to Dodge City as well as all points in between the Kansas landscape—permeate the great sacred feminine energies . . .

Sacred Feminine Vulva of Kansas

Exceptional

Phenomenal

Womanhood

Loving kindness

Greatness

Passionate friendships

Forming social bonds

Compassion and empathy

Trustworthy loyalty

Sacred Feminine of Kansas

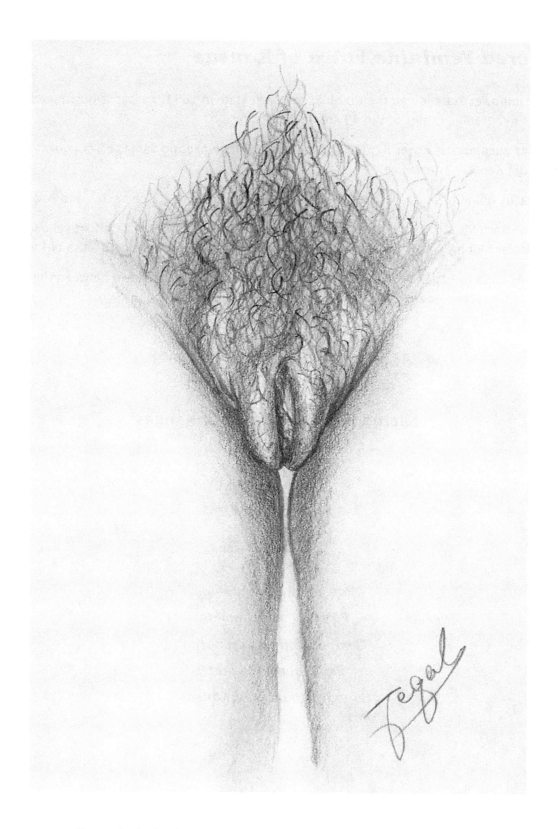

Kentucky is feminine country. Represented by a nice vulva image, if I must say so! — Artist JEGAL

33

Sacred Feminine Vulva of Kentucky

The Blue Grass State, wedged between the Ohio River and the Appalachian Mountains, joined the Union as the 15th State in 1792. Kentucky encompasses over 40,000 square miles.

Mammoth Cave is one of the Seven Natural Wonders of the modern world.

The first Kentucky Derby was run in 1875.

Kentucky is the birthplace of Abraham Lincoln.

The Cardinal flies to a branch on a Tulip tree, and a Goldenrod flower blooms below the canopy, all state symbols to glorify the uniqueness of Kentucky.

From Lexington to Louisville to Boonesboro to Fort Knox to Covington to Owensboro to Paducah as well as all points in between the Kentucky landscape—permeate the great sacred feminine energies . . .

Sacred Feminine Vulva of Kentucky

Bluegrass country

Natural wonders of nature

Serene and tranquil

Femininity

Amplified energy

Excitement and enthusiasm

Always having fun

Influencing

Perpetual love

Sacred Feminine of Kentucky

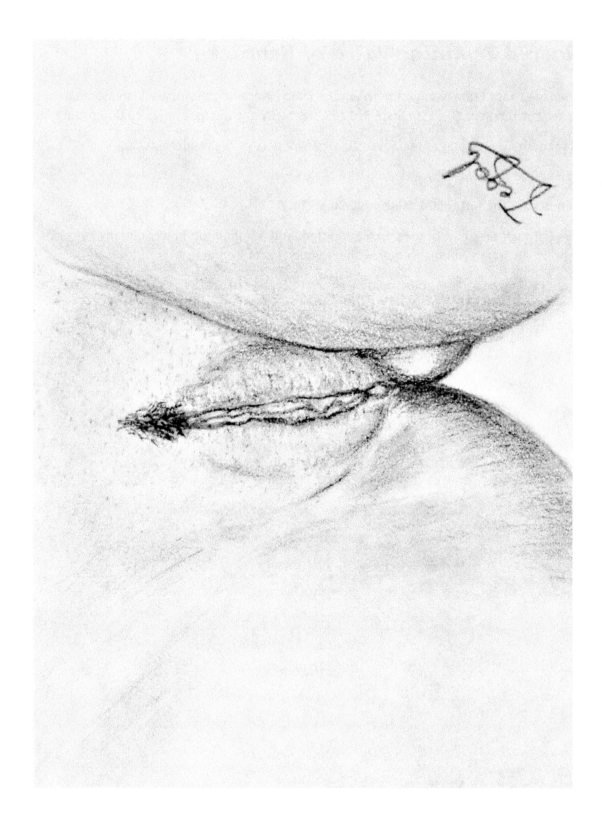

Louisiana women are represented by a sweet honey. She posed in many variations until I froze the moment with this sketch. Just lovely! — Artist JEGAL

Sacred Feminine Vulva of Louisiana

The Pelican State joined the Union as the 18th State in 1812. Louisiana encompasses over 48,000 square miles. Its lands are divided into parishes and its waterways into bayous.

Louisiana is named after King Louis XIV of France. The French and Creole heritage is firmly settled in the area.

The annual Mardi Gras celebration in New Orleans has been held every year since 1838. Louisiana is also home to the birthplace of American Jazz.

The Eastern Brown Pelican flies to a branch on a Bald Cypress tree, and a Southern Magnolia flower blooms below the canopy, all state symbols to glorify the uniqueness of Louisiana.

From Shreveport to Natchitoches to Baton Rouge to Bogalusa to Morgan City to New Orleans to Lake Pontchartrain and out on the Mississippi River as well as all points in between the Louisiana landscape—permeate the great sacred feminine energies . . .

Sacred Feminine Vulva of Louisiana

Creole bayou

Unique rhythms

Womanhood femininity

Fun-loving nature

Dancing and singing

Bonding with everyone

Especially family and friends

Harmonious vibrations

Perpetuate in life

Sacred Feminine of Louisiana

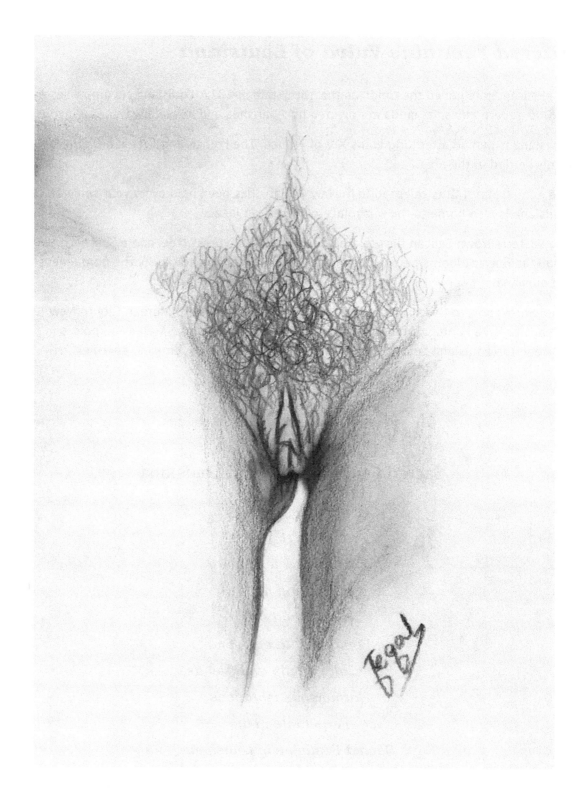

Maine is majestic, wonderful, heartwarming, soft and sensual. I could go on and on. Great poser. — *Artist JEGAL*

Sacred Feminine Vulva of Maine

The Pine Tree State joined the Union as the 23rd State in 1820. Maine is the most northeasterly section of the country—immense forests of pine, fir, and spruce, as well as over 2,000 lakes.

Maine encompasses over 33,000 square miles.

The Chickadee bird flies to a branch on an Eastern White Pine tree, and a Pine Cone falls below the canopy, all state symbols to glorify the uniqueness of Maine.

From Portland to Lewiston to Augusta to Bangor to Presque Isle to Moosehead Lake to Mount Katahdin and through Acadia National Park and the Appalachian Trail as well as all points in between the Maine landscape—permeate the great sacred feminine energies . . .

Sacred Feminine Vulva of Maine

Natural nature wonderland

Forests, lakes and mountains

Women, woman, female

Blazing the trails

Guiding, directing, influencing

Leading

From compassion to empathy

Caring about people

Human nature: sisterhood, brotherhood

Sacred Feminine of Maine

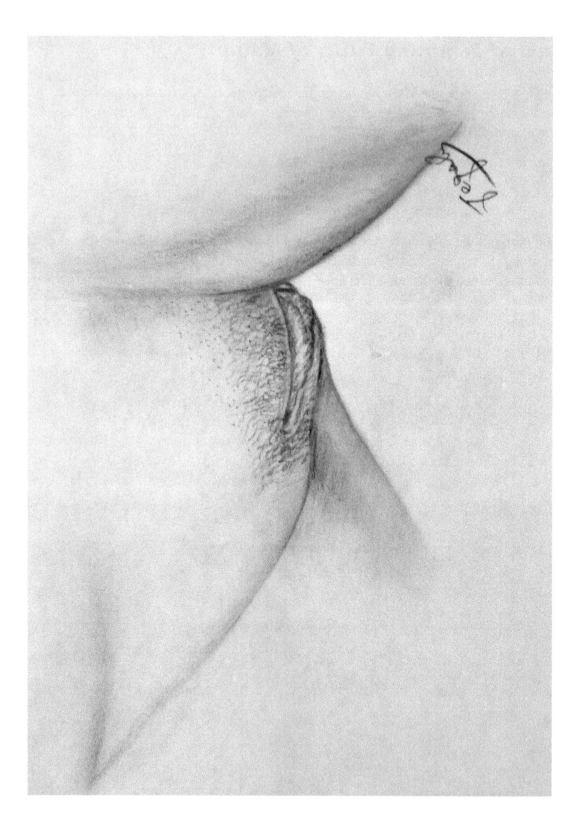

Maryland is bursting with great femininity. And I found just the right poser.
Her vulva is striking to meditate on. Serene. Tranquil. — *Artist JEGAL*

Sacred Feminine Vulva of Maryland

The Old Line State, joined the Union as the seventh State in 1788. Maryland encompasses over 10,000 square miles and is home to the nation's largest bay, the Chesapeake, which separates Maryland's mainland from the Eastern Shore.

In 1814 Francis Scott Key composed "The Star-Spangled Banner" when Fort McHenry survived British bombardment.

Maryland is home to the U.S. Naval Academy and Goddard Space Center.

The Baltimore Oriole flies to a branch on a White Oak tree, and a Black-eyed Susan flower blooms below the canopy, all state symbols to glorify the uniqueness of Maryland.

From Hagerstown to Frederick to Silver Spring to Baltimore to Annapolis to Ocean City as well as all points in between the Maryland landscape—permeate the great sacred feminine energies . . .

———— ⌣ ————

Sacred Feminine Vulva of Maryland

Great land

Unique in character

Female, woman

Connecting and influencing

Networks of people

Across all racial divides

Supportive of basic human rights

Loving one another

Sisterhood of humanity

Sacred Feminine of Maryland

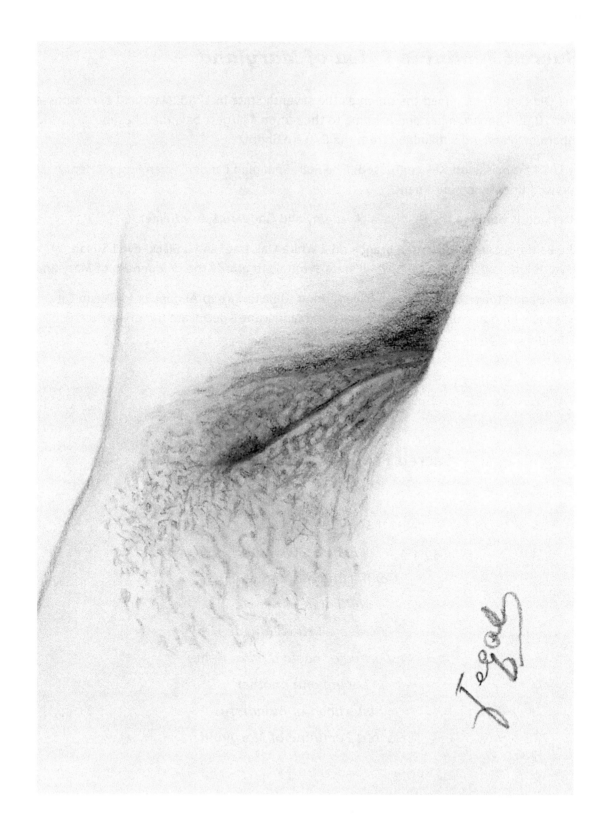

Massachusetts females are represented by a gorgeous poser.
What a sight. Lovely. — Artist JEGAL

Sacred Feminine Vulva of Massachusetts

The Bay State joined the Union as the sixth State in 1788. Massachusetts encompasses over 8,000 square miles.

In 1620 the Mayflower landed at Plymouth Rock. In 1636 Harvard college was founded, the first in America. In 1775, Concord, Massachusetts gave birth to the American Revolution.

The Chickadee flies to a branch on an American Elm tree, and a Mayflower blooms below the canopy, all state symbols to glorify the uniqueness of Massachusetts.

From Cape Cod to Martha's Vineyard to Nantucket to Boston to Cambridge to Salem to Lowell to Worcester to Springfield to Concord as well as all points in between the Massachusetts landscape—permeate the great sacred feminine energies . . .

Sacred Feminine Vulva of Massachusetts

America's foundation

Great historic lands

Teaming with femininity

Seeking liberty

Perpetually

Freedom to be free

Leading force in society

Faithful friend

Compassionate citizen

Sacred Feminine of Massachusetts

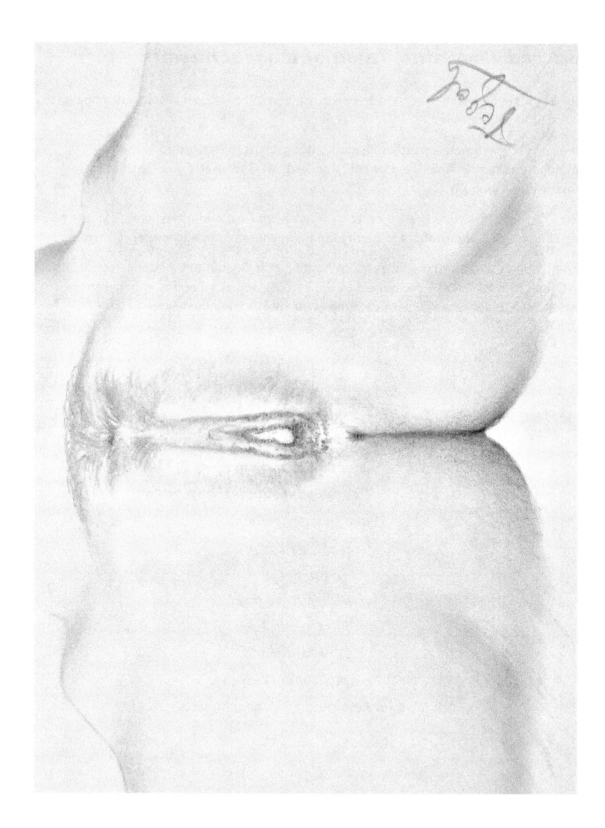

Michigan women are represented by a fine feminine poser. In fact,
her sketch image is one of my top favorites. Wow! — *Artist JEGAL*

Sacred Feminine Vulva of Michigan

The Wolverine State joined the Union as the 26th State in 1837. Michigan is the only state made from two peninsulas. The state encompasses over 58,000 square miles.

The name "Michigan" is Chippewa for "Great Lake."

Michigan is the only state to border on four of the five Great Lakes: Lake Huron, Lake Erie, Lake Superior, and Lake Michigan.

The Mackinac Bridge is one of the world's longest suspension bridges.

The Robin flies to a branch on a White Pine tree, and an Apple Blossom flower blooms below, all state symbols to glorify the uniqueness of Michigan.

From Detroit to Lansing to Grand Rapids to Traverse City to Saginaw to Dearborn to Ann Arbor to Kalamazoo to Alpena to Sault Ste. Marie to Marquette and sailing on the Great Lakes as well as all points in between the Michigan landscape—permeate the great sacred feminine energies . . .

<hr>

Sacred Feminine Vulva of Michigan

Purity of nature

Transcendent qualities

Womanhood

Pleasing, tranquil and serene

Energetic queen

Leading and influencing

Guiding force

Constructive, productive

Revitalizing

Sacred Feminine of Michigan

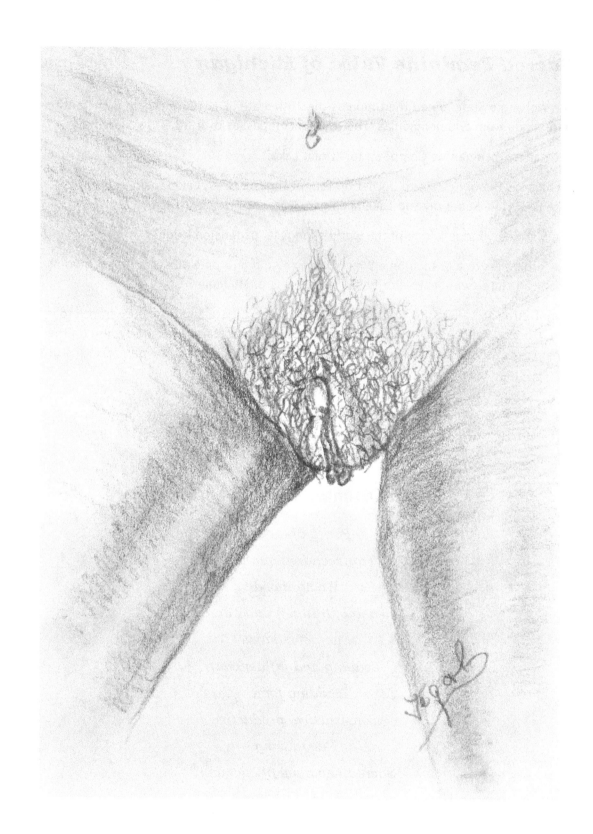

Minnesota is special to me. Such nice proportions.
Pure art. — Artist JEGAL

Sacred Feminine Vulva of Minnesota

The North Star State joined the Union as the 32nd State in 1858. Minnesota encompasses over 84,000 square miles—with over 4,000 square miles of water—laced with rivers and thousands of lakes.

Minnesota means "sky-colored water" in Sioux.

Minnesota is the greatest iron-ore producing state—60% of the nation's supply, some 50 million tons per year. The Mesabi and Vermilion Ranges contain the world's largest iron ore deposits.

Lake Itasca is the source of the start of the Mississippi River.

The Loon flies to a branch on a Norway Pine tree, and a Showy Lady's Slipper flower blooms below, all state symbols to glorify the uniqueness of Minnesota.

From Minneapolis to Duluth to Rochester to St. Paul to Little Falls, as well as all points in between the Minnesota landscape—permeate the great sacred feminine energies . . .

Sacred Feminine Vulva of Minnesota

Great land of 10,000 lakes

Water constantly flowing

Flourishing womanhood

Populates the regions

Giving, sharing, loving

Empathy for everyone

Family and friends

Epic loves

A great insatiable passion for life

Sacred Feminine of Minnesota

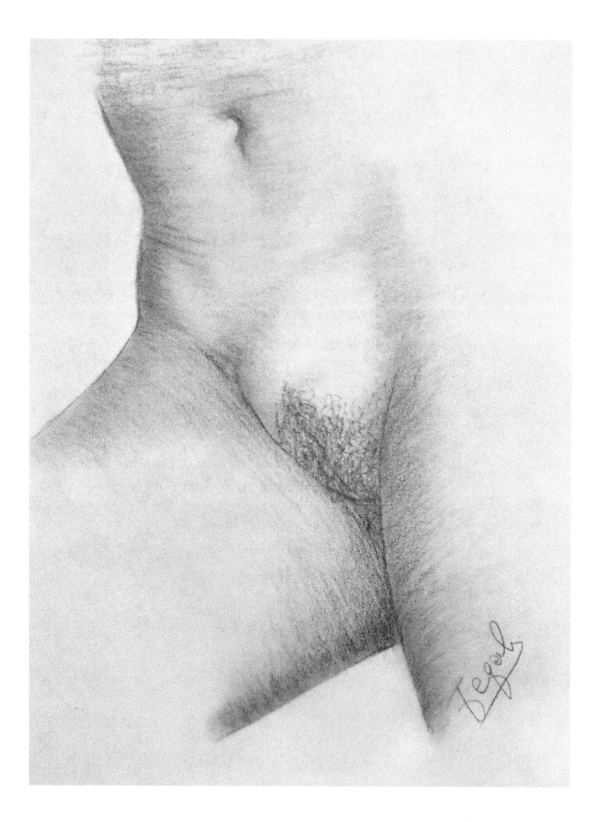

*Mississippi is incredible, lovely, fascinating. What a pleasure
to sketch her vulva.* — *Artist JEGAL*

Sacred Feminine Vulva of Mississippi

The Magnolia State joined the Union as the 20th State in 1817. Mississippi encompasses over 47,000 square miles.

"Mississippi" means "father of waters" in Choctaw. The state derives its unique character from "King Cotton" and the great river.

In 1541 the explorer DeSoto discovered the Mississippi River (he died and was buried in the river in 1542).

The Mockingbird flies to a branch on a Magnolia tree, and a Magnolia flower blooms nearby, all state symbols to glorify the uniqueness of Mississippi.

From Jackson to Natchez to Hattiesburg to Vicksburg to Gulfport to Biloxi as well as all points in between the Mississippi landscape—permeate the great sacred feminine energies . . .

Sacred Feminine Vulva of Mississippi

Mighty river land

Southern homestead

Womanhood

Femininity

Blooming like a magnolia tree

Authentic natural flow

In the know

Loving life

Guiding light

Sacred Feminine of Mississippi

Missouri is showtime. What a sketch. I love being an artist and locating such fine art to celebrate. — *Artist JEGAL*

Sacred Feminine Vulva of Missouri

The Show–Me State joined the Union as the 24th State in 1821. Missouri encompasses over 69,000 square miles—the entire eastern boundary is the Mississippi river.

Missouri is the Gateway to the West—on St. Louis' riverfront is Saarinen's Gateway Arch, the tallest national monument.

Missouri is America's largest producer of beer.

The Eastern Bluebird flies to a branch on a Dogwood tree, and a Hawthorn flower blooms below the canopy, all state symbols to glorify the uniqueness of Missouri.

From Kansas City to St. Joseph to Joplin to Jefferson City to Springfield to St. Louis to Lake of the Ozarks, and sailing up and down the Mississippi river as well as all points in between the Missouri landscape—permeate the great sacred feminine energies . . .

———

Sacred Feminine Vulva of Missouri

Show-me

Know me

Set the soul free

Femininity

Magnetic and powerful

Natural

Authentic

Energetic influence

Confluence of force

Sacred Feminine of Missouri

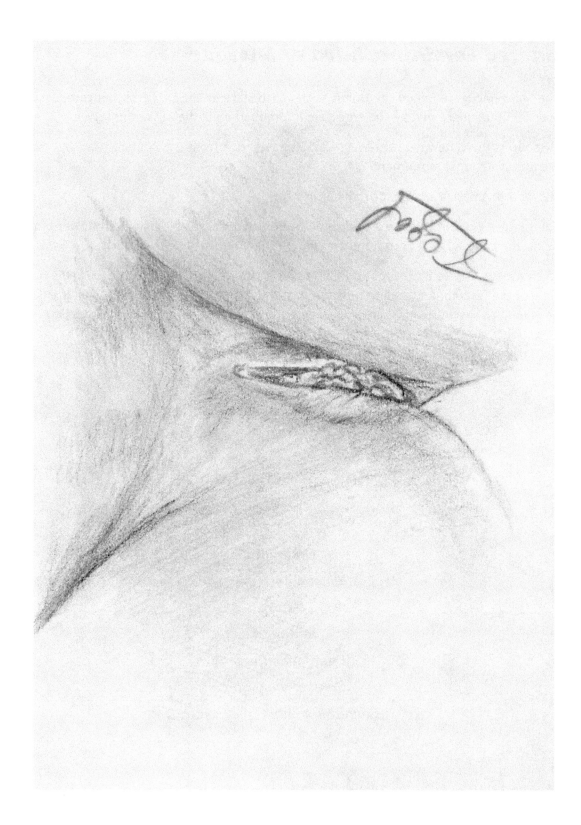

Montana is quite the vulva image. I was looking for something different and I found it. Thank you, my lovely anonymous lady. — *Artist JEGAL*

Sacred Feminine Vulva of Montana

The Treasure State joined the Union as the 41st State in 1889. Montana encompasses over 147,000 square miles—forests cover one quarter of the state, which includes the towering forested mountains of the Continental Divide.

Over five million of the state's 100 million acres are Indian Lands.

In 1876 General Custer and over 200 soldiers were killed at Little Big Horn by Sioux and Cheyenne.

Montana is home to Glacier National Park and 10 other national parks.

The Western Meadowlark flies to a branch on a Ponderosa Pine tree, and a Bitterroot flower blooms below, all state symbols to glorify the uniqueness of Montana.

From Billings to Glendive to Helena to Butte to Great Falls to Missoula, as well as all points in between the Montana landscape—permeate the great sacred feminine energies . . .

―――⌣―――

Sacred Feminine Vulva of Montana

Great forested mountains

Raw nature everywhere

The magnetic draw

Womanhood femininity

Set the mind free

To liberate self

Awareness

Togetherness

Union

Sacred Feminine of Montana

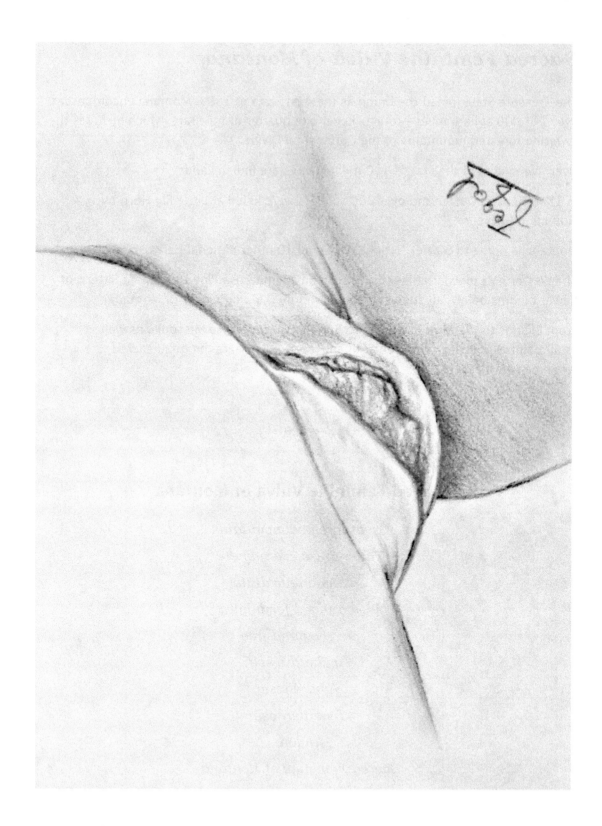

Nebraska was a challenge to find. Then I got lucky and found my poser.
Her look was just right. — Artist JEGAL

Sacred Feminine Vulva of Nebraska

The Cornhusker State joined the Union as the 37th State in 1867. Nebraska encompasses over 77,000 square miles.

Food processing, based on the state's agriculture, is its largest industry.

The Western Meadowlark flies to a branch on an American Elm tree, and a Goldenrod flower blooms below the canopy, all state symbols to glorify the uniqueness of Nebraska.

From Beatrice to Minden to North Platte to Kingsley Dam to Lincoln to Omaha as well as all points in between the Nebraska landscape—permeate the great sacred feminine energies . . .

~

Sacred Feminine Vulva of Nebraska

Farmwork

Feeds the populous

Femininity influences the day

Magnetic sway

Pointing the way

To great happenings

Each and every day

Fun and laughter

Friendship and family

Sacred Feminine of Nebraska

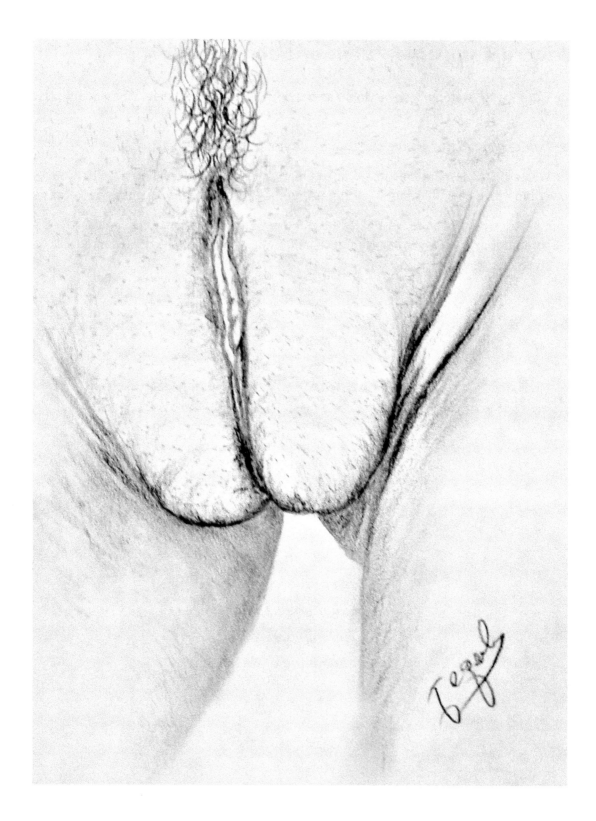

*Nevada is very charming. Her pose was exactly what
I was looking for.* — *Artist JEGAL*

Sacred Feminine Vulva of Nevada

The Silver State joined the Union as the 36th State in 1864. Nevada encompasses over 110,00 square miles—range after range of mountains and endless desert. As one of the least permanently populated states, the millions of visitors to Reno and Las Vegas provide over half of the state's income.

The discovery of silver deposits in 1859 brought the first surge of people to Nevada.

Carson City is the smallest state capital in the U.S.

In 1936 the Hoover Dam and Lake Mead were put in operation—a man-made wonder, the highest in the Western Hemisphere.

Nevada is home to the Atomic Energy Commission as well as to the secret Area 51.

The Mountain Bluebird flies to a branch on a Bristlecone Pine tree, and a Sagebrush flower blooms below, all state symbols to glorify the uniqueness of Nevada.

From Lake Tahoe to Death Valley to Reno to Virginia City to Carson City to Ely to Las Vegas as well as all points in between the Nevada landscape—permeate the great sacred feminine energies . . .

Sacred Feminine Vulva of Nevada

Desert utopia

Magnet for the world

Entertainment and gambling

Womanhood abounds

Straightforward and practical

Lifetime dream potential

Ultimate fantasies set free

Mysterious

Mystical

Sacred Feminine of Nevada

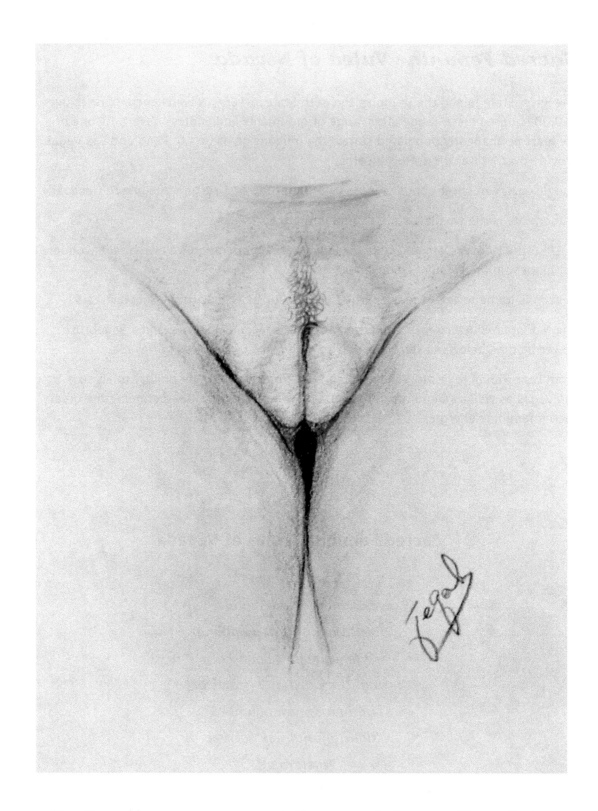

New Hampshire women are represented by a very alluring poser. She captivates.
I bottled her lovely essence in the image. — Artist JEGAL

Sacred Feminine Vulva of New Hampshire

The Granite State became the ninth State to ratify the Constitution on June 17, 1788. New Hampshire encompasses over 9,000 square miles—over 80% of the state is covered with forests.

At 6,288 feet, Mount Washington is the highest peak in New England.

The quarries of New Hampshire have provided the stone for many of the nation's monuments and public buildings, such as the Library of Congress in D.C.

The Purple Finch flies to a branch on a White Birch tree, and a Purple Lilac flower blooms below the canopy, all state symbols to glorify the uniqueness of New Hampshire.

From Nashua to Manchester to Hillsboro to Concord to Portsmouth to the Appalachian Trail to Lake Winnipesaukee to sailing up and down the Merrimack River as well as all points in between the New Hampshire landscape—permeate the great sacred feminine energies . . .

Sacred Feminine Vulva of New Hampshire

Natural nature

Harmonious character

Nurturing kindnesses

Femininity

High quality

Profundity

Purity

Good family

Lasting friendships

Sacred Feminine of New Hampshire

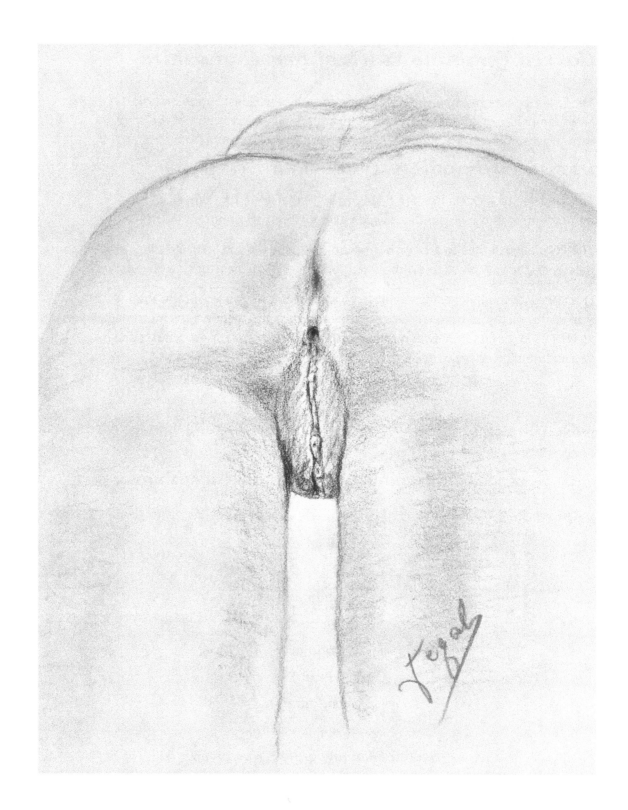

New Jersey is fantastic. I loved doing this sketch. I captured a nice moment between artist and subject. — Artist JEGAL

Sacred Feminine Vulva of New Jersey

The Garden State was the third State to ratify the Constitution on December 3, 1787. New Jersey encompasses over 8,000 square miles. The Delaware Water Gap is a deep gorge cut through the Kittatinny Mountains.

During the American Revolution, nearly 100 battles were fought in New Jersey.

The research laboratory of Thomas Edison and his over 1,000 inventions is at Menlo Park.

The Eastern Goldfinch flies to a branch on a Red Oak tree, and a Purple Violet flower blooms below the canopy, all state symbols to glorify the uniqueness of New Jersey.

From Atlantic City to Camden to Trenton to Princeton to Newark to Jersey City to Patterson as well as all points in between the New Jersey landscape—permeate the great sacred feminine energies. . .

Sacred Feminine Vulva of New Jersey

Great land

Strategic foothold

Womanhood

Inspiring

Generating harmonies

Vibratory rhythms

Bonding

Generations of families

With caring and kindness

Sacred Feminine of New Jersey

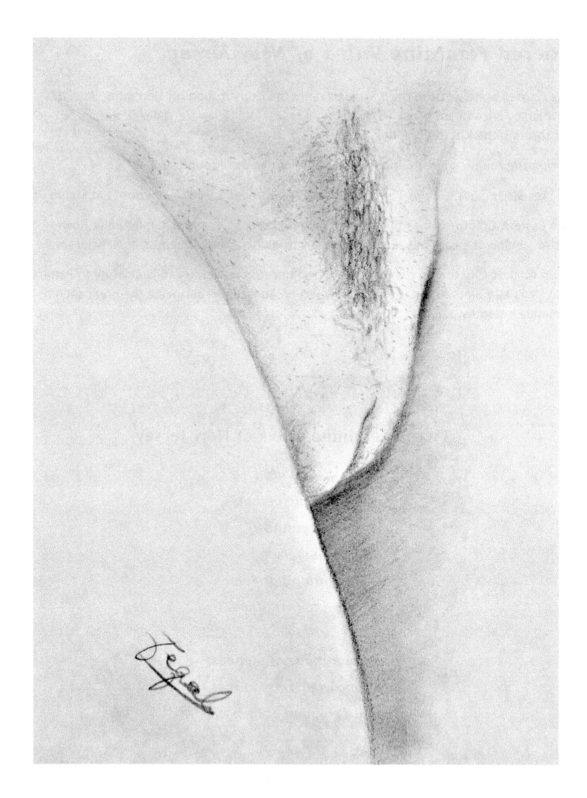

New Mexico is very fine. She wears a pleasant nakedness.
Enchanting, mysterious. — Artist JEGAL

Sacred Feminine Vulva of New Mexico

The Land of Enchantment joined the Union as the 47th State in 1912. New Mexico encompasses over 121,000 square miles.

New Mexico is a center for atomic research. In 1942 the Manhattan Project started at Los Alamos where, on July 16, 1945, the first nuclear weapon was detonated. New Mexico is the nation's greatest source of uranium ore.

New Mexico is home to the world's largest caverns in Carlsbad.

New Mexico is home to four large Indian reservations—Pueblo and Navajo. Each August, New Mexico, near Gallup, is host to tribes from all across North America at the Inter-Tribal Indian Ceremonial.

The Roadrunner flies to a branch on a Piñon tree, and a Yucca flower blooms below the canopy, all state symbols to glorify the uniqueness of New Mexico.

From Albuquerque to Tucumcari to Gallup to Alamogordo to Carlsbad to Santa Fe, as well as all points in between the New Mexico landscape—permeate the great sacred feminine energies . . .

Sacred Feminine of New Mexico

Southwest region

Native American homelands

Feminine presence

Absorbing the environment

Monuments to love

Womanhood

Balancing the daily ebb and flow

Making a go

At a life well lived

Sacred Feminine of New Mexico

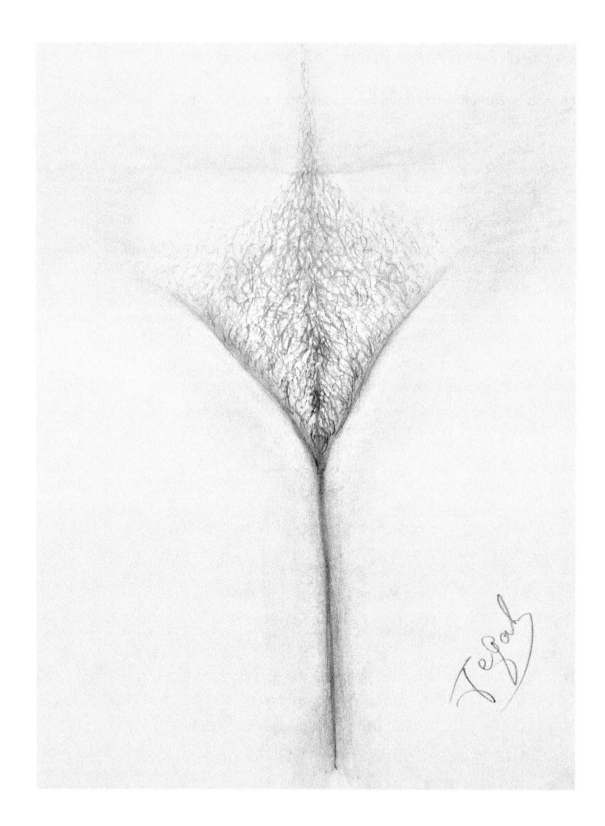

New York is hot! What a unique lady poser. She made my
pulse rate jump. — Artist JEGAL

Sacred Feminine Vulva of New York

The Empire State joined the Union as the 11th State in 1788. New York encompasses over 49,000 square miles and is home to the largest city in the Western Hemisphere and the trade capital of the world. New York City was also the first capital of the U.S.

New York is home to the U.S. Military Academy at West Point, Cooperstown Baseball Hall of Fame, and the United Nations and Statue of Liberty in New York City.

The Erie Canal opened in 1825.

The Bluebird flies to a branch on a Sugar Maple tree, and a Red Rose blooms below the canopy, all state symbols to glorify the uniqueness of New York.

From sailing on the Hudson River to Lake Champlain to the St. Lawrence river to Niagara Falls to Lake Ontario to Lake Erie to Buffalo to Rochester to Syracuse to Utica to Albany to New York City, as well as all points in between the New York landscape—permeate the great sacred feminine energies . . .

Sacred Feminine Vulva of New York

Great state, greatest city

Home to all peoples of the earth

Feminine influences

Far and wide

Promoting positivity and goodwill

Common bonding

Love for humanity

Women lead

Set your soul free

Sacred Feminine of New York

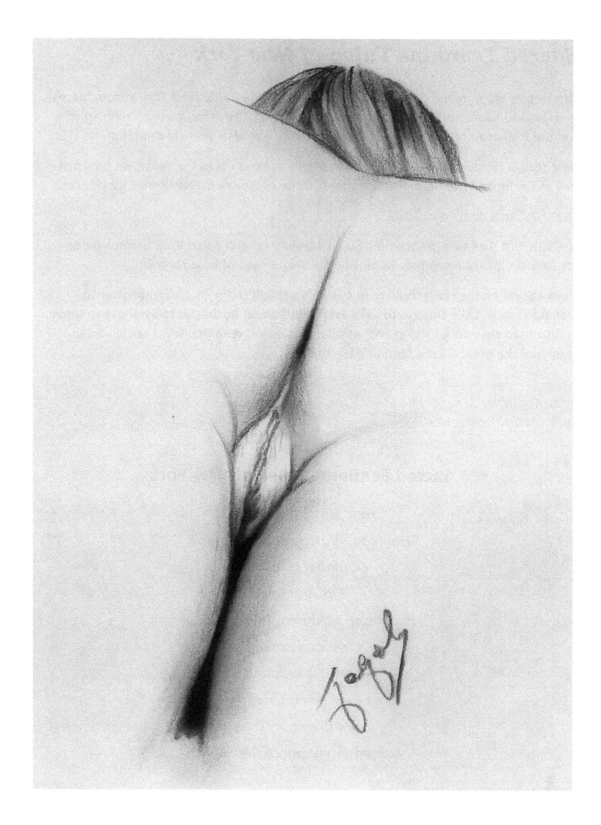

*North Carolina is intoxicating. What a rush. I very much enjoyed
bringing this image alive on paper.* — *Artist JEGAL*

Sacred Feminine Vulva of North Carolina

The Tar Heel State joined the Union as the 12th State to ratify the Constitution in 1789. North Carolina encompasses over 52,000 square miles—a string of islands, the Outer Banks, protects much of the mainland from the open sea.

In the Blue Ridge Mountains of North Carolina are Great Smoky Mountains National Park, almost 800 square miles of untouched forest, with Mount Mitchell, eastern America's highest peak.

In 1903 the Wright Brothers flew the first powered aircraft at Kitty Hawk.

North Carolina grows more tobacco than any other state.

The Cardinal flies to a branch on a Longleaf Pine tree, and a Dogwood flower blooms below, all state symbols to glorify the uniqueness of North Carolina.

From Ashville to Charlotte to Fayetteville to Winston-Salem to Greensboro to Durham to Raleigh to Wilmington to sailing on the Catawba River to Cape Fear River to Neuse River to Roanoke River, as well as all points in between the North Carolina landscape— permeate the great sacred feminine energies . . .

Sacred Feminine Vulva of North Carolina

Unique nature

Natural wonders

Womanhood

High quality

Acts of kindness

Loving friendships

Authentic

Life of passion

Hopeless romantic

Sacred Feminine of North Carolina

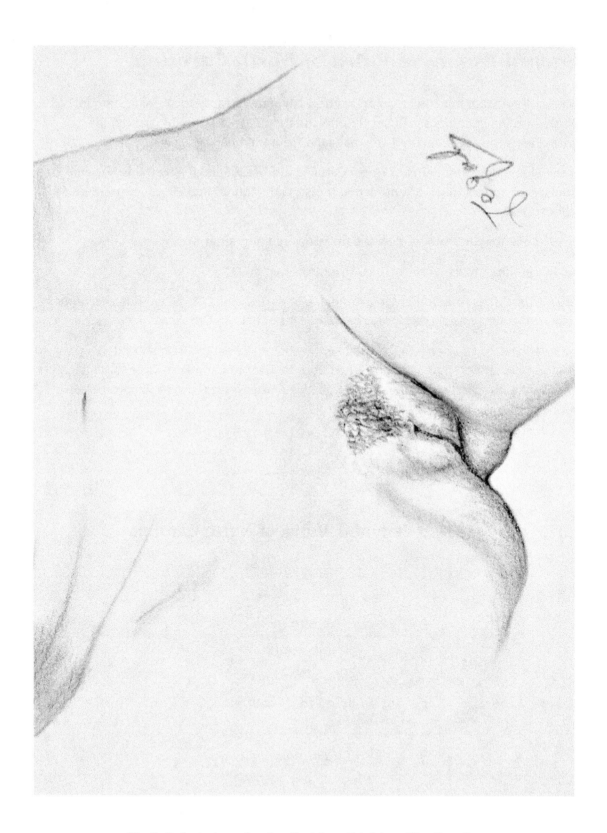

*North Dakota is so lovely. Just breathtaking. She lit a fire
in my brain.* — *Artist JEGAL*

Sacred Feminine Vulva of North Dakota

The Sioux State joined the Union as the 39th State in 1889. North Dakota encompasses over 70,000 square miles. The Red River of the North is the only northern-flowing river in the U.S.

Theodore Roosevelt National Memorial Park is located in the Badlands.

North Dakota's principal crop is wheat.

The Western Meadowlark flies to a branch on an American Elm tree, and a Wild Prairie Rose flower blooms below the canopy, all state symbols to glorify the uniqueness of North Dakota.

From Grand Forks to Fargo to Bismarck to Pembina to Minot to the Garrison Reservoir to the Missouri River to the Sheyenne River as well as all points in between the North Dakota landscape—permeate the great sacred feminine energies . . .

Sacred Feminine Vulva of North Dakota

Miles of prairies

Great farmlands

Feminine presence

Bringers of poise and equilibrium

Inspiring and influencing

Goodwill and social bonding

Harmonious

Content of character

Everlasting

Sacred Feminine of North Dakota

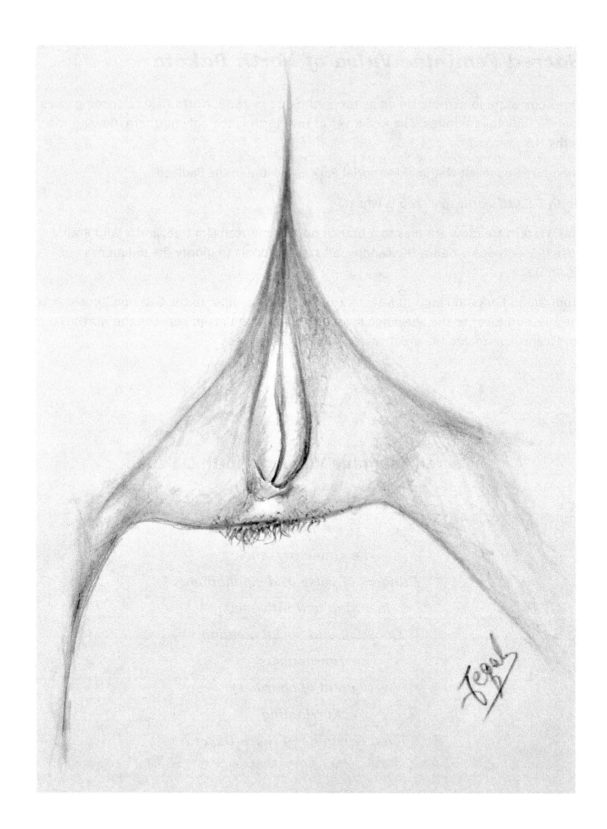

Ohio is captivating. I stared longer than I sketched, until finally the sketch was burnished into my brain before I actually put my artist pen to paper. — Artist JEGAL

Sacred Feminine Vulva of Ohio

The Buckeye State joined the Union as the 17th State in 1803. Ohio encompasses over 41,000 square miles. "Ohio" means "Great" in Indian language.

Seven U.S. Presidents came from Ohio: Garfield, McKinley, Harding, Grant, Harrison, Taft, and Hayes.

Ohio is the number-one state in rubber and plastics production.

The Cardinal flies to a branch on an Ohio Buckeye tree, and a Scarlet Carnation blooms below the canopy, all state symbols to glorify the uniqueness of Ohio.

From Toledo to Dayton to Columbus to Cincinnati to Akron to Youngstown to Cleveland and sailing along the Ohio River and in Lake Erie, as well as all points in between the Ohio landscape—permeate the great sacred feminine energies . . .

Sacred Feminine Vulva of Ohio

Strategic center

Commerce thoroughfare

Female presence

Enlightens and inspires

Boldly developing

Constructive connections

Reflecting great love for

Family and friends

With empathy and compassion

Sacred Feminine of Ohio

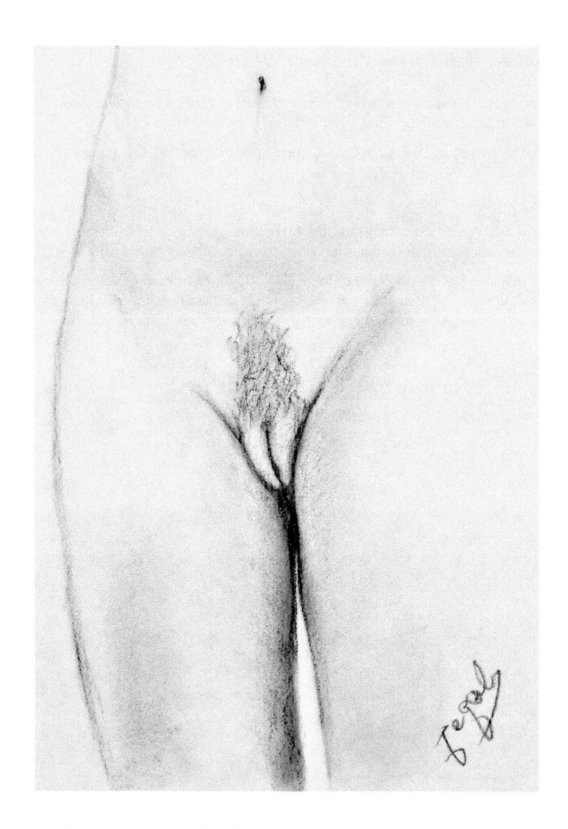

Oklahoma is unforgettable. What a find for my artistic collection. The poser is willing, able and daring, and yet she looks so innocent. — Artist JEGAL

Sacred Feminine Vulva of Oklahoma

The Sooner State joined the Union as the 46th State in 1907. Oklahoma encompasses over 69,000 square miles.

The history of Oklahoma is largely a history of the Indians. In the 1830s, Indian territory was established by the U.S. Government: Cherokee, Creek, Choctaw, Chickasaw, Seminole—all sovereign independent nations, under U.S. protection. Over 60 tribes now live in Oklahoma.

Tulsa is the oil capital of the world.

The Scissor-tailed Flycatcher flies to a branch on a Redbud tree, and a Oklahoma Rose flower blooms below the canopy, all state symbols to glorify the uniqueness of Oklahoma.

From Oklahoma City to Norman to Lawton to Muskogee to Tulsa to Lake of the Cherokees to the Red River to the Cimarron River as well as all points in between the Oklahoma landscape—permeate the great sacred feminine energies . . .

Sacred Feminine Vulva of Oklahoma

Oil-rich land

Guiding abode, hosting hand

Feminine womanhood

Inspiring inroads

Passionate mind

Compassionate heart

Bonding togetherness

Love and friendship

Fulfilling a lifetime

Sacred Feminine of Oklahoma

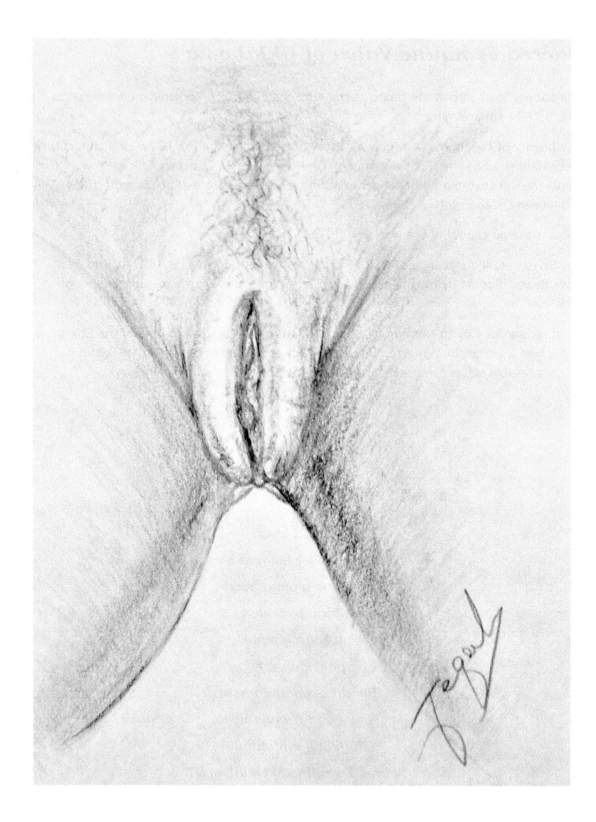

*Oregon is artful and daring. Many poses until settling on this
elegant sketch. Lovely woman. — Artist JEGAL*

Sacred Feminine Vulva of Oregon

The Beaver State joined the Union as the 33rd State in 1859. Oregon encompasses over 96,000 square miles. Oregon has more standing saw timber than any other state, and almost every year it leads the nation in lumbering.

Oregon means "beautiful water" in Algonquin.

Thousands of pioneers endured the Oregon Trail to settle in the river valleys.

The Columbia River provides about one-third of all the hydroelectric potential of the continental U.S.

In 1904 Oregon adopted the primary election system—the state's most distinctive and enduring contribution to the American way of life.

The Western Meadowlark flies to a branch on a Douglas Fir tree, and a Oregon Grape flower blooms below the canopy, all state symbols to glorify the uniqueness of Oregon.

From Portland to Astoria to Salem to Corvallis to Eugene to Crater Lake to Hell's Canyon to Mount Hood to boating the Willamette River and the Snake River and the Columbia River as well as all points in between the Oregon landscape—permeate the great sacred feminine energies . . .

Sacred Feminine Vulva of Oregon

Exceptional nature

Northwest

Feminine presence

Establishing loving kindness

Inspiring, influencing

Guiding

Bonding relationships

Friendships of loyalty and trust

Heightened consciousness

Sacred Feminine of Oregon

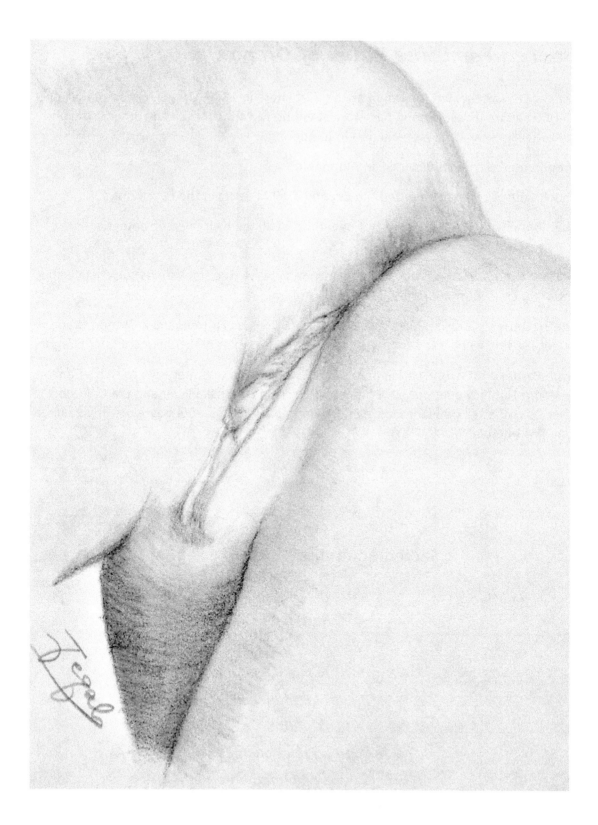

Pennsylvania women are represented by a flamboyant free-spirit poser. Such feminine wonder. — *Artist JEGAL*

Sacred Feminine Vulva of Pennsylvania

The Keystone State was the second State to join the Union by adopting the U.S. Constitution in 1787. Pennsylvania encompasses over 45,000 square miles. Founder William Penn built a society on the principles of civil and religious freedom, especially with Quakers.

Pennsylvania was the cultural, economic and political center of colonial America. In 1776 congress adopted the Declaration of Independence. In 1777 the Articles of Confederation were drafted. In 1787 the Constitution of the United States was drafted and adopted. In 1790 Philadelphia became the capital of the U.S. for 10 years.

Pennsylvania is America's steel capital. Pennsylvania's most celebrated citizen is the scientist, writer, philosopher and statesman, Benjamin Franklin.

The Ruffed Grouse flies to a branch on an Eastern Hemlock tree, and a Mountain Laurel flower blooms below the canopy, all state symbols to glorify the uniqueness of Pennsylvania.

From Pittsburgh to Erie to Harrisburg to Gettysburg to Scranton to Wilkes–Barre to Allentown to Lancaster to Philadelphia to sailing on the Delaware River and the Susquehanna River and the Allegheny River and the Monongahela River and the Ohio River as well as all points in between the Pennsylvania landscape—permeate the great sacred feminine energies . . .

Sacred Feminine Vulva of Pennsylvania

Foundational land

Potential realized

Womanhood leading

Forging new trails of liberation

Blazing forth

Pragmatic idealism

Sisterhood/brotherhood

Transcendent and exceptional

Constructive goodwill to all

Sacred Feminine of Pennsylvania

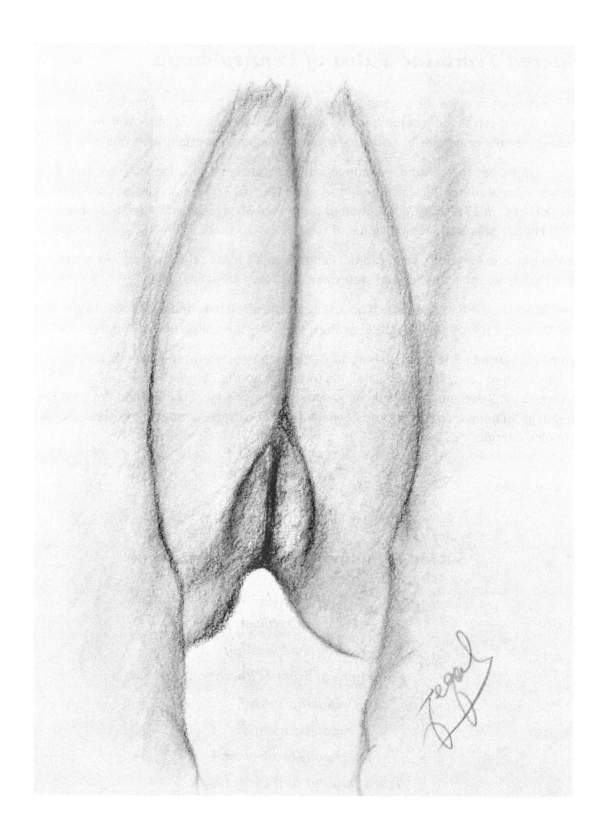

Rhode Island women are represented by a very fine poser. I love the natural proportions. The art is something to behold. — *Artist JEGAL*

Sacred Feminine Vulva of Rhode Island

"Little Rhody" joined the Union as the 13th State to adopt the U.S. Constitution in 1790. Rhode Island ranks 50th in size, but was one of the first of the 13 colonies to declare independence. Rhode Island encompasses 1,214 square miles in a 37–by–48–mile state.

Providence, the capital and New England's second largest city, is the costume jewelry center of the world.

Rhode Island is home to a major naval base, which includes the Naval War College.

The Rhode Island Red Bird flies to a branch on a Red Maple tree, and a Red Violet flower blooms below the canopy, all state symbols to glorify the uniqueness of Rhode Island.

From Narragansett Bay to Aquidneck Island to Block Island Sound to Providence to Pawtucket to Woonsocket to Cranston to Warwick to Newport to Westerly as well as all points in between the Rhode Island landscape—permeate the great sacred feminine energies . . .

Sacred Feminine Vulva of Rhode Island

Red Clay State

Small, but first-rate

Feminine presence

Instilling warmth and goodwill

Confident

Emotional balance

At work and play

Gratitude and thankfulness every day

Blessing to all

Sacred Feminine of Rhode Island

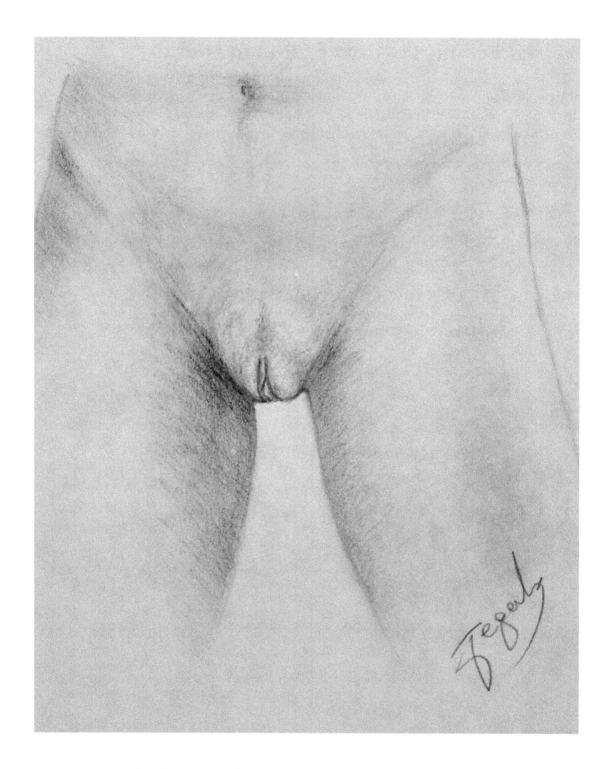

South Carolina is stunning. Sketching natural raw femininity captures the essence and power of a woman. — *Artist JEGAL*

Sacred Feminine Vulva of South Carolina

The Palmetto State became the eighth State to adopt the U.S. Constitution in 1788. South Carolina encompasses over 31,000 square miles.

South Carolina was the first state to secede from the Union. The Fort Sumpter National Monument signifies the start of the Civil War in 1861.

South Carolina is the home of the U.S. Marine Base on Parris Island.

The Carolina Wren bird flies to a branch on a Cabbage Palm tree, and a Yellow Jessamine flower blooms below the canopy, all state symbols to glorify the uniqueness of South Carolina.

From Columbia to Greenville to Anderson to Aiken to Florence to Charleston to Brookgreen Gardens to Cypress Gardens to Middleton Gardens to boating on Lake Marion and Lake Moultrie and the Atlantic Ocean as well as all points in between the South Carolina landscape—permeate the great sacred feminine energies . . .

Sacred Feminine Vulva of South Carolina

Southern pride

Multiple floral gardens

Womanhood, sisterhood

Harmonious emanations

Positive goodwill

Social bonding

Nourishing wisdom

Fun and laughter

Filling the special moments of each day

Sacred Feminine of South Carolina

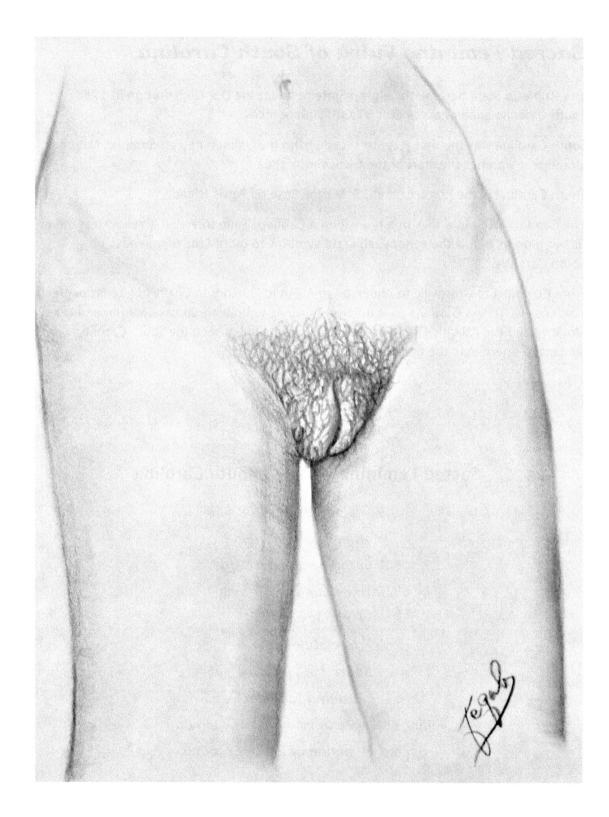

South Dakota has a beautiful landscape, sculpted for art's sake.
I gaze in wonder. — Artist JEGAL

Sacred Feminine Vulva of South Dakota

The Coyote State joined the Union as the 40th State in 1889. South Dakota encompasses over 77,000 square miles; 90% of the land is in farms and ranches. The Missouri River cuts through the center of the state.

In 1876 the largest goldmine in the U.S., the Homestake, was discovered in the Black Hills (Sioux Land) of South Dakota. Soon after the Sioux War followed during which Crazy Horse defeated Custer. The Black Hills is a region revered by the Indians as the home of powerful spirits. South of the Black Hills are the fabled badlands—eroded gorges and bare hills where scientists have discovered fossils of prehistoric animals.

South Dakota is home to Mount Rushmore, where sculptor Gutzon Borglum carved giant portraits in stone of four presidents: Washington, Jefferson, Lincoln, and T. Roosevelt.

The Ringnecked Pheasant bird flies to a branch on a Black Hills Spruce tree, and a American Pasqueflower blooms below the canopy, all state symbols to glorify the uniqueness of South Dakota.

From Sioux Falls to Yankton to Pierre to Rapid City to the Cheyenne Reservation to the Pine Ridge Reservation to the Rosebud Reservation to boating on the Missouri River as well as all points in between the South Dakota landscape—permeate the great sacred feminine energies . . .

～

Sacred Feminine Vulva of South Dakota

Farming homeland

Natural abode

Feminine presence

Magnificence

Transcendent

Devoted passion

Cherished friendships

Treasure-filled gratitude

Living harmoniously

Sacred Feminine of South Dakota

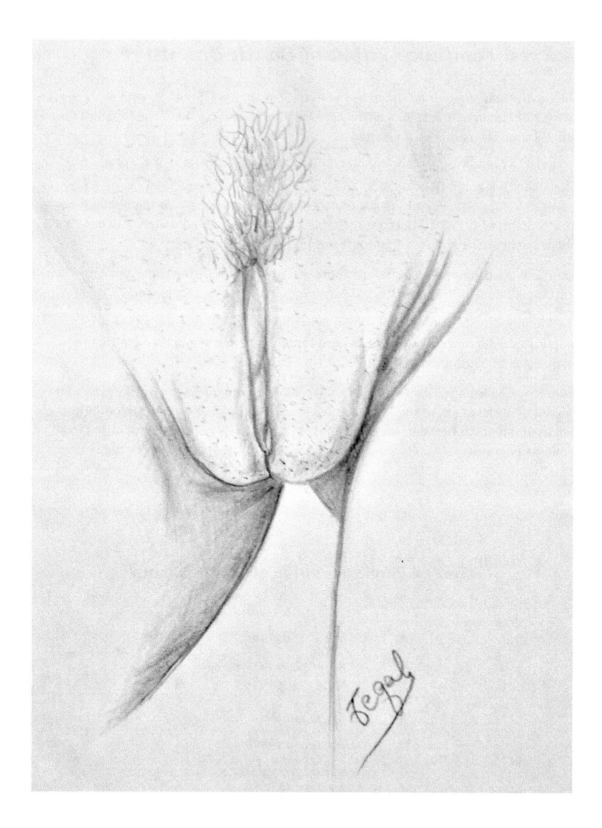

Tennessee is beautiful art exposed. Such a body,
what a form. — *Artist JEGAL*

Sacred Feminine Vulva of Tennessee

The Volunteer State joined the Union as the 16th State in 1796. Tennessee encompasses over 41,000 square miles, including three large dams on the Tennessee river.

Tennessee has the nation's richest sources of zinc and marble.

Tennessee is home to the Atomic Energy Museum at Oak Ridge—the plant that made the first atomic bomb.

The Mockingbird flies to a branch on a Tulip Poplar tree, and a Purple Iris flower blooms below the canopy, all state symbols to glorify the uniqueness of Tennessee.

From Memphis to Nashville to Columbia to Chattanooga to Knoxville to Greenville to Kingsport to the Blue Ridge Mountains and the Cumberland Mountains to the Cumberland Gap and boating on the Mississippi River, as well as all points in between the Tennessee landscape—permeate the great sacred feminine energies . . .

Sacred Feminine Vulva of Tennessee

Musical foundations

Harmonizing

Exceptional womanhood

Empowering lady love

Leading the way

Majestic and glorious

Noteworthy passions

Loving kindness

Tender affections

Sacred Feminine of Tennessee

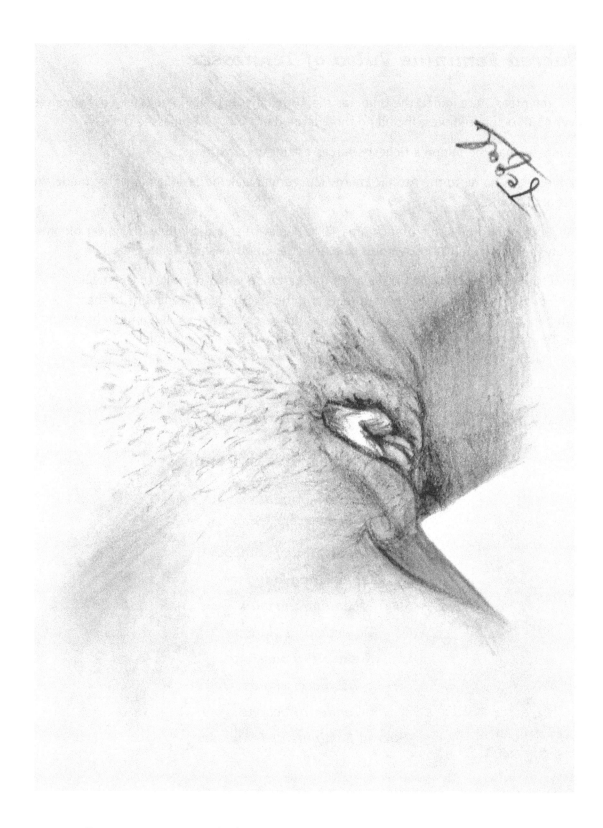

Texas arouses my curiosity. Such a special place to sketch. Her vulva is art defined, all its own. — *Artist JEGAL*

Sacred Feminine Vulva of Texas

The Lone Star State joined the Union as the 28th State in 1845. Texas was an Independent Republic from 1836–45. Texas encompasses over 267,000 square miles (second only to Alaska in size—greatest in the contiguous states, the lower 48). The U.S. border with Mexico is 800 miles along the Rio Grande.

Almost half of the oil and natural gas produced in the U.S. comes from Texas. In 1901 the largest oil well ever discovered was the Spindletop gusher near Beaumont.

Texas is home to more farms than any other state as the leading producer of livestock and crops. The state is also the greatest U.S. source of salt, magnesium and sulphur, and one of the largest producers of helium.

The Mockingbird flies to a branch on a Pecan tree, and a Bluebonnet flower blooms below the canopy, all state symbols to glorify the uniqueness of Texas.

From Corpus Christi to San Antonio to Galveston to Houston to Austin to Waco to Fort Worth to Dallas to Amarillo to El Paso to Laredo to the Gulf of Mexico to the Rio Grande River to the Colorado River to the Brazos River to the Sabine River to the Red River as well as all points in between the Texas landscape—permeate the great sacred feminine energies . . .

—⁓—

Sacred Feminine Vulva of Texas

Lone Star State

Mighty land

Great feminine presence

Pervades in all directions

Empowering vitality

Animating vibrancy

Constructive goodwill

Loving kindness

Tender-heartedness

Sacred Feminine of Texas

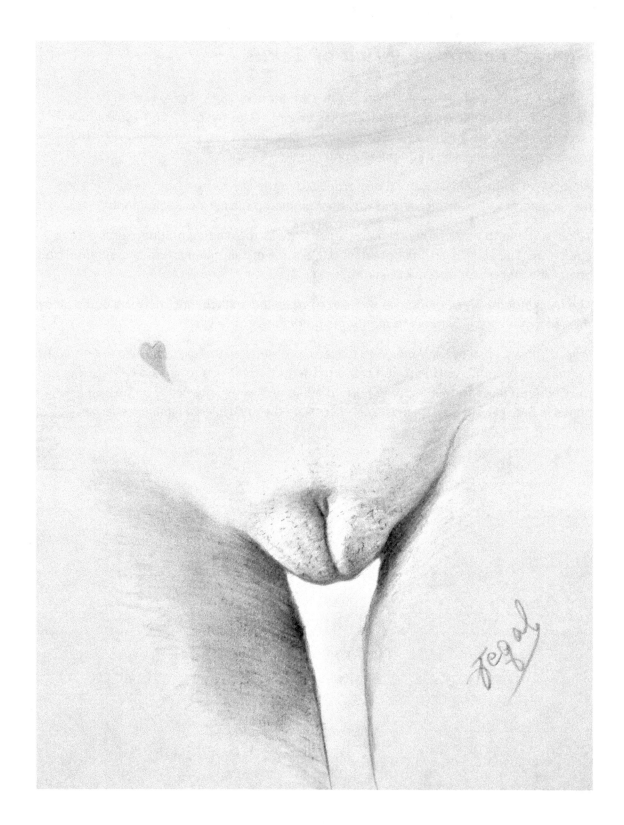

*Utah astounds me. Fantastic sight. My artist's eye is
challenged to look deep.* — *Artist JEGAL*

Sacred Feminine Vulva of Utah

The Beehive State joined the Union as the 45th State in 1896. Utah encompasses over 84,000 square miles of large, practically unpopulated areas such as mountains in the northeast, desert in the west, vast plateaus, striking gorges and geological formations in the south.

Utah is dominated by Mormon culture. Brigham Young led the first Mormon settlers to Salt Lake Valley in 1847, on a 1,000-mile trek to escape persecution, and establish the first settlement.

Utah is home to the Navajo Reservation and the Uintah Reservation. Utah is also home to the world's largest open-pit copper mine.

The California Gull bird flies to a branch on a Blue Spruce tree, and a Sego Lily flower blooms below the canopy, all state symbols to glorify the uniqueness of Utah.

From the Great Salt Lake to Utah Lake to Lake Powell to the Colorado River to the Green River to Zion National Park to Bryce Canyon to the Natural Bridge to Salt Lake City to Ogden to Provo as well as all points in between the Utah landscape—permeate the great sacred feminine energies . . .

Sacred Feminine Vulva of Utah

Remarkable land

Full of natural wonders

Womanhood

Guiding and influencing

Inspiring and motivating

Compassion and empathy

Spirit of love

Liberating

Familial social bonds

Sacred Feminine of Utah

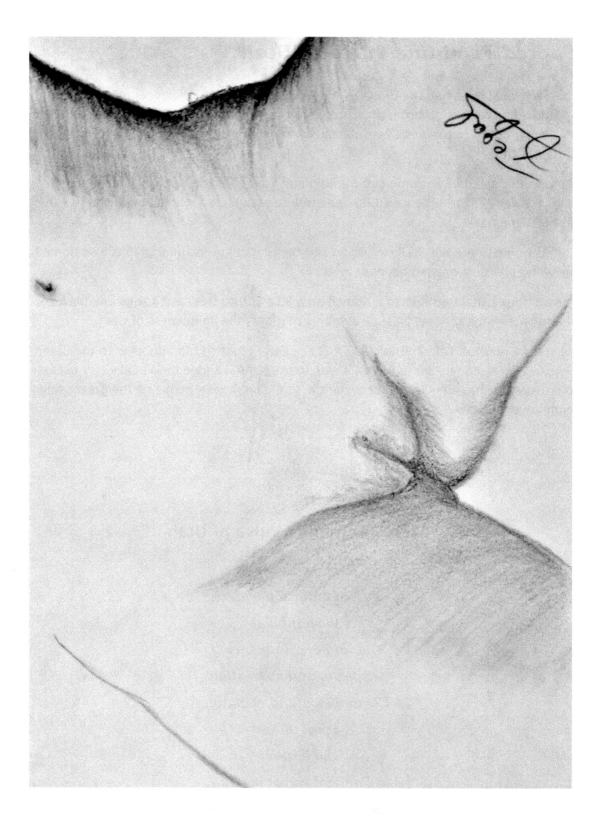

Vermont women are represented by an enchanting poser. She has many poses to offer until we agree on just the right one. So unique and original. — *Artist JEGAL*

Sacred Feminine Vulva of Vermont

The Green Mountain State joined the Union as the 14th State in 1791. Vermont encompasses over 9,000 square miles dominated by the rocky, forested mountains—70% of the state is made up of forests.

Vermont lies between Lake Champlain and the Connecticut River—the only inland New England State.

Vermont has the largest granite quarry in the world.

The Appalachian Trail winds through southern Vermont.

The Hermit Thrush bird flies to a branch on a Sugar Maple tree, and a Red Clover flower blooms below the canopy, all state symbols to glorify the uniqueness of Vermont.

From Montpelier to Barre to Rutland to Bennington to Burlington to sailing on the Connecticut River and the Winooski River and the Otter River, as well as all points in between the Vermont landscape—permeate the great sacred feminine energies . . .

Sacred Feminine Vulva of Vermont

Forested mountains

Never-ending green canopy

Femininity emanates

Electromagnetic attractions

Absorbing and receptive

Pacific and connective

Natural granite

Raw nature

Teeming with life

Sacred Feminine of Vermont

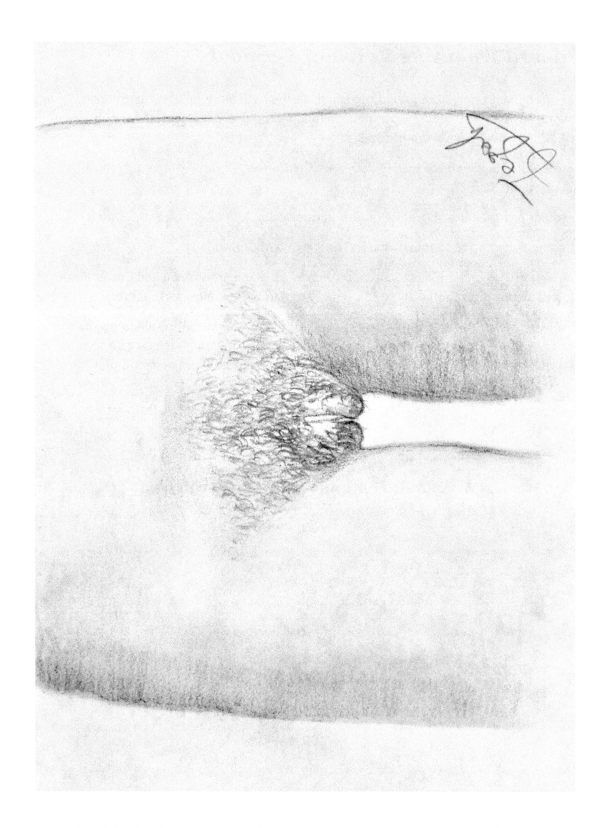

Virginia elevated my pulse rate. Astounding curves and proportion. I could sketch again and again. — Artist JEGAL

Sacred Feminine Vulva of Virginia

The Old Dominion was the 10th State to ratify the Constitution in 1788. Virginia encompasses over 40,000 square miles and was named after Elizabeth I, the Virgin Queen of England. In 1607 the first colony was established in America at Jamestown.

Known as "the Mother of Presidents," Virginia produced four of the new nation's five presidents: Washington, Jefferson, Madison, and Monroe.

Two of Virginia's national historic landmarks are the restored Colonial Capital of Williamsburg and Arlington National Cemetery.

Virginia was the site for ending two of our nation's great wars: Revolutionary and Civil — from Yorktown Battlefield to Appomattox Courthouse.

The Cardinal flies to a branch on a Flowering Dogwood tree, and a Dogwood Flower blooms below the canopy, all state symbols to glorify the uniqueness of Virginia.

From Richmond to Norfolk to Arlington to Alexandria to Charlottesville to Roanoke to sailing on the Potomac River and the Rappahannock River and the James River and the Shenandoah River, as well as all points in between the Virginia landscape—permeate the great sacred feminine energies . . .

Sacred Feminine Vulva of Virginia

Great mythic land

Making liberation stand

The transcendent feminine hand

Influencing

Guiding

Directing

Nurturing

Sisterhood and brotherhood

All for one and one for all

Sacred Feminine of Virginia

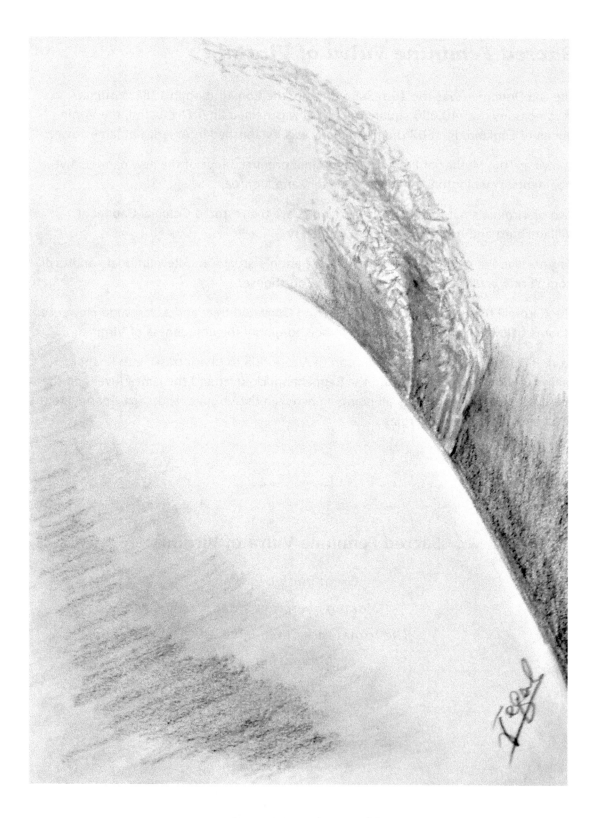

Washington women are friendly. I had a good time doing this sketch. — *Artist JEGAL*

Sacred Feminine Vulva of Washington

The Evergreen State joined the Union as the 42nd State in 1889. Named after George Washington, the State of Washington encompasses over 68,000 square miles, over half of which is forest land.

Washington is the gateway to Alaska and the Orient.

Mount Rainer is the highest peak at 14,410 feet.

The American Goldfinch bird flies to a branch on a Western Hemlock tree, and a Coast Rhododendron blooms below the canopy, all state symbols to glorify the uniqueness of Washington.

From Puget Sound to Seattle to Tacoma to Olympia to Hanford to Spokane to Olympic National Park to the Yakima Reservation to the Colville Reservation to boating on the Columbia River to Grand Coulee Dam (world's largest concrete dam) and the Bonneville Dam, as well as all points in between the Washington landscape—permeate the great sacred feminine energies . . .

Sacred Feminine Vulva of Washington

The Great Evergreen Land and Mount Rainer

And the Grand Coulee Dam

Womanhood emanates

Provoking love

Friendship and kindness

Neighborly helping hand

Northwest gateway

Raw nature entranceway

Land a lady will love

Sacred Feminine of Washington

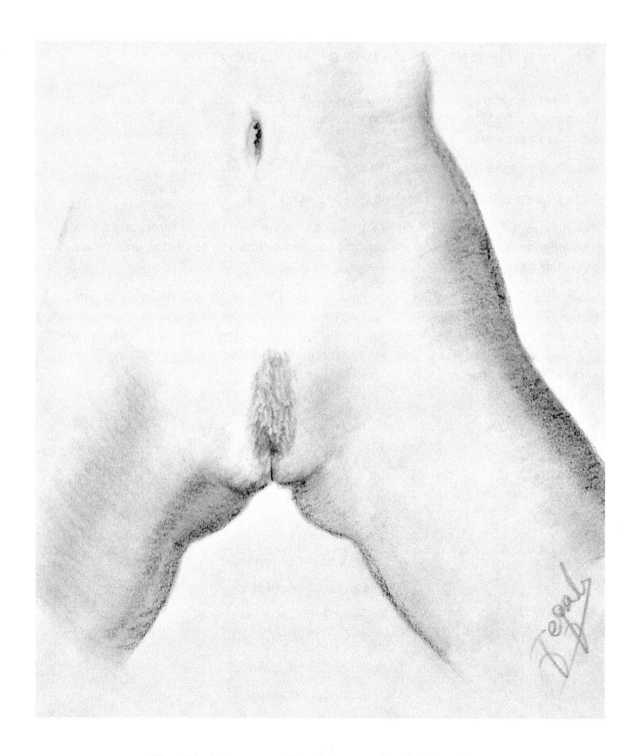

West Virginia was exciting for me to sketch. I found my
mountaineer poser. — Artist JEGAL

Sacred Feminine Vulva of West Virginia

The Mountain State joined the Union as the 35th State in 1863. West Virginia encompasses over 24,000 square miles, including almost a million acres of national forests.

West Virginia was born in the Civil War: it seceded from Virginia when that state seceded from the Union. The unusual shape of the state, with its northern and eastern panhandles, resulted from settlement of border disputes with Pennsylvania, Maryland, and Virginia.

West Virginia has more mountains than any other state east of the Rockies. Coal, oil and timber are its greatest natural resources. The state has over 200 significant natural springs: Big Spring, White Sulphur Springs, and Berkeley Springs.

The Cardinal flies to a branch on a Sugar Maple tree, and a Rosebay Rhododendron blooms below the canopy, all state symbols to glorify the uniqueness of West Virginia.

From Wheeling to Morgantown to Oak Hill to Huntington to Racine to Charleston to sailing on the Greenbrier River and the Monongahela River and the Ohio River and the Kanawha River, as well as all points in between the West Virginia landscape—permeate the great sacred feminine energies . . .

———— ⌣ ————

Sacred Feminine Vulva of West Virginia

Great Mountain State

Home of natural springs

Feminine persuasions

Sanctity

Natural nature

Emanations and undulations

Landscape wonders

Flowing rivers

Sweet sisterhood

Sacred Feminine of West Virginia

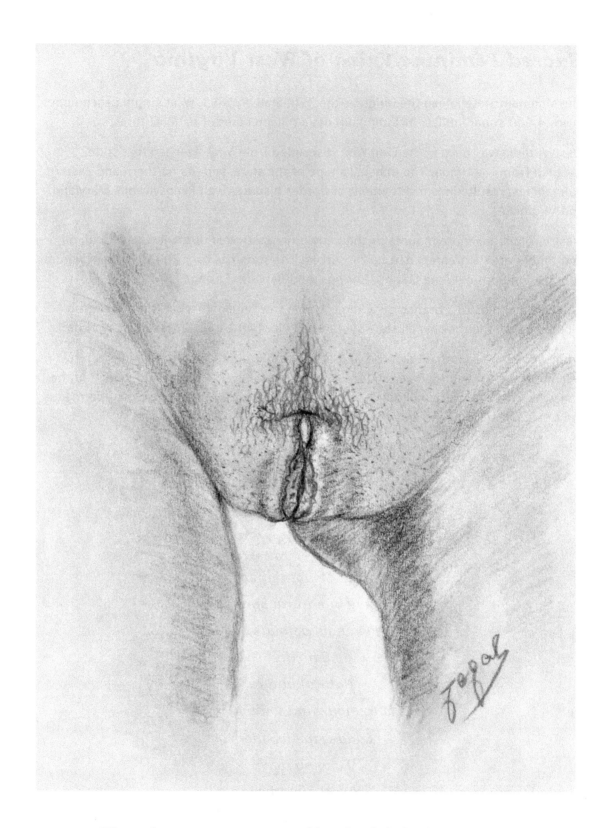

*Wisconsin women are represented by a lovely lady. I'm enchanted.
Another fine piece of vulva art.* — *Artist JEGAL*

Sacred Feminine Vulva of Wisconsin

The Badger State joined the Union as the 30th State in 1846. Wisconsin encompasses over 56,000 square miles—bound by Lake Superior in the north, Lake Michigan to the east, and the Mississippi River bounds southerly on the west as the Wisconsin River cuts through the middle of the state, north to southwest, joining the Mississippi.

Wisconsin leads the nation in the production of beer and is the dairy capital of America.

The state has 8,500 lakes and 10,000 rivers and streams.

Wisconsin was the birthplace of the Republican Party in 1854.

The Robin flies to a branch on a Sugar Maple tree, and a Butterfly Violet flower blooms below the canopy, all state symbols to glorify the uniqueness of Wisconsin.

From Milwaukee to Racine to Green Bay to Oshkosh to Ripon to Prairie du Chien to Madison to the Wisconsin Dells, as well as all points in between the Wisconsin landscape— permeate the great sacred feminine energies . . .

Sacred Feminine Vulva of Wisconsin

America's Dairy Capital

Home to boundless rivers, lakes and streams

Women leading

Multitudes of productions

Earnest living

Loving life

Giving back and receiving in kind

Promoting sisterhood and brotherhood

Across this great land

Sacred Feminine of Wisconsin

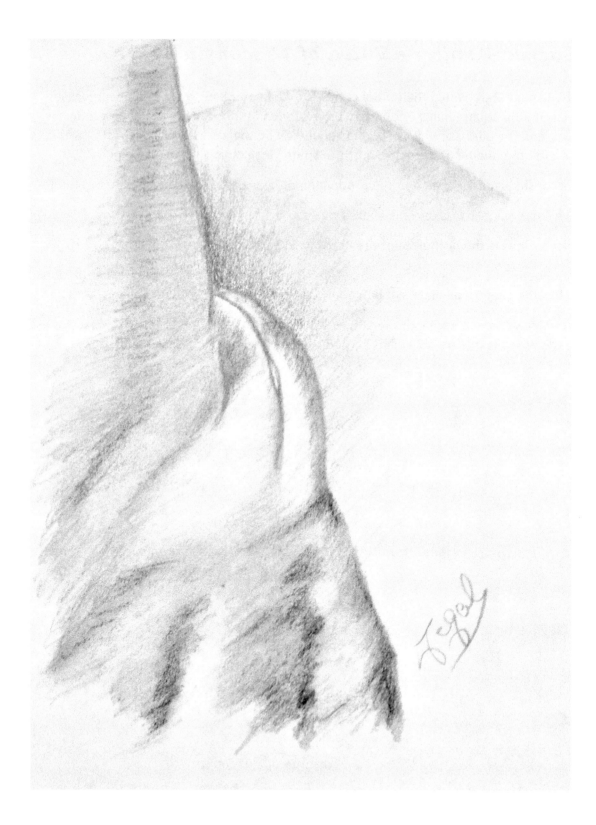

*Wyoming sets my mind ablaze. Sketching the raw essence, the splendor
of this vulva, had a real impact on me. Wow! — Artist JEGAL*

Sacred Feminine Vulva of Wyoming

The Equality State joined the Union as the 44th State in 1890. Wyoming encompasses over 97,000 square miles. The Continental Divide follows a series of ranges through Wyoming, the second highest state, with an average elevation of 6,700 feet.

In 1869 the Wyoming Territory became the first government in the world to grant women equal rights. The key industries in Wyoming are cattle raising and oil refining.

For many generations, thousands of native Indians lived in Wyoming: Arapahoe, Sioux, Shoshone, Bannock, Kiowa, and Pawnee. The Wind River Reservation is a 1.8-million-acre tract. Buried on the reservation is Sacajawea, the Shoshone girl guide of the Lewis and Clark Expedition.

The Western Meadowlark bird flies to a branch on a Plains Cottonwood tree, and a Wyoming Paintbrush flower blooms below the canopy, all state symbols to glorify the uniqueness of Wyoming.

From Yellowstone National Park to Devil's Tower to Grand Teton National Park to Cheyenne to Laramie to Casper to Sheridan to Cody to boating on the North Platte River and the Big Horn River and the Green River and Jackson Lake and Yellowstone Lake, as well as all points in between the Wyoming landscape—permeate the great sacred feminine energies . . .

———◡———

Sacred Feminine Vulva of Wyoming

Home to historic national parks

And a great Indian reservation

From girls to women

Female persuasion rules the day and the way

The clear natural air

From on high the Continental Divide

Loving the experiences of life

Hopeful happenings always around the bend

Tranquility and serenity

Sacred Feminine of Wyoming

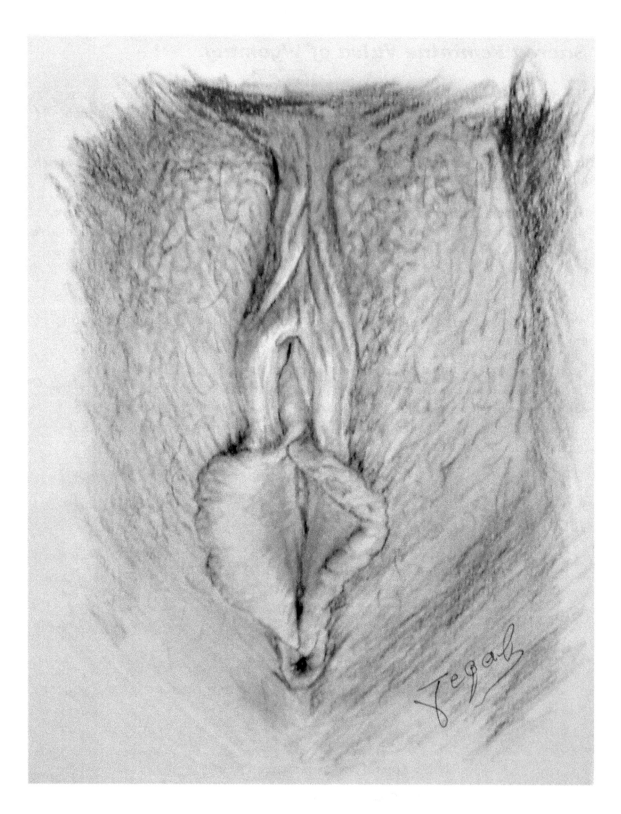

Washington DC is cosmopolitan in every way. My poser suggested I do a close-up sketch and, of course, I went along. Such exquisite grace, power and beauty. Flower petal lips! — Artist JEGAL

101

Sacred Feminine Vulva of Washington D.C. (District of Columbia)

Washington D.C. was founded on July 16, 1790 by Congress as the new home of the national government, the capital of the United States of America, located on the Potomac River bordering Maryland and Virginia.

On June 11, 1800, Washington D.C. becomes the permanent U.S. Capital; George Washington himself chose the site in 1791. John Adams was the first President in the White House.

D.C. is only 68.34 square miles; the District of Columbia is a square that looks like a diamond on a map.

Washington D.C. has over 20 million visitors each year.

The Bald Eagle flies to a branch on an Oak tree, and a Rose blooms below the canopy, as a North American Bison roams by—all national symbols to glorify the uniqueness of Washington D.C.

From monuments and statues to specialty museums and government buildings—the White House, Lincoln Memorial, Washington Monument, Library of Congress, United States Capital, Supreme Court of the United States, U.S. Department of Treasury, National Archives Building as well as all points in between the Washington D.C. landscape—permeate the great sacred feminine energies . . .

———— ⌣ ————

Sacred Feminine Vulva of Washington D.C.

Power and prestige

National and world leadership

Monuments to mankind

Womanhood femininity pronounced

Guiding and influencing

Provoking and directing

Compassionate and nurturing

Holding progressive ideals and

Loving life

Sacred Feminine of Washington D.C.

A Closing Interview with The Artist JEGAL

QUESTION: **How do you wish for your work on this project to be received?**

Artist JEGAL: With an open mind, open heart and open arms by those attracted to this project. To inspire people to appreciate human life on an intimate level.

QUESTION: **What about negative reactions and criticism?**

Artist JEGAL: What is there to be negative about? What is there to criticize? If it's not your thing then you don't buy it, you don't look at it, you don't discuss the contents. This is not porno; this is art. As an artist I am enraptured and inspired by feminine energies.

QUESTION: **Will you contact some of your anonymous posers and let them know of your new published work of art?**

Artist JEGAL: Most likely not. Each will discover it on their own if it is meant to be.

QUESTION: **Are you concerned about being shunned by certain people in society because of this work?**

Artist JEGAL: Not at all. The people who know me know who I am and what I'm about. I love people. I appreciate life. I have goodwill toward everyone I meet. As an artist I am curious and my mind is always at work. And the most curious thing of all is humanity, especially women. I am not mean or nasty or vulgar with anyone. I give out love and kindness and I receive love and kindness in return.

QUESTION: **It was a long winding road, well over a decade, to complete your quest of sketching a V poser in each state. Are you amazed at yourself in your quiet moments when you are alone, for having set upon and completing this quest?**

Artist JEGAL: No, I'm not amazed. It was natural for me to set upon this quest. It was as natural as it is to breathe, eat or sleep. Having the goal drove me to carry on. It went from a little side hobby at first, to a full-blown obsession. A positive obsession. The energy from this project aided me in my painting pursuits as well, that had nothing to do with the V project. It fuels my creative energy!

QUESTION: **So, the key to your creativity are the thoughts, emotions and visions inspired by femininity?**

Artist JEGAL: Yes! I agree with that statement. The feminine soul is the key to making this whole world go round. To making my experience of life go round. My artistic mind engages and creates and produces because of the constant inspirations from feminine energies.

QUESTION: **The sacred feminine is a driving force in your life, obviously. Do you have anything else you would like to express on the subject?**

Artist JEGAL: The power of femininity is universal and truly has no bounds. Women are the wonderful creations of the Almighty. I have the utmost reverence and respect for the sacred feminine in all women.

QUESTION: **Are you fulfilled as an artist with the product of this project?**

Artist JEGAL: Yes and no. I love the final expression of my idea in this book. But I would love to take it to the next level and travel the earth and do a new book, say, "Shades of V in the World" or something to that effect.

QUESTION: **Have you captured the mystery and mystique you hoped for?**

Artist JEGAL: I believe I have with my 51 sketches. Some may resonate with an individual more than others. But as a whole, taken altogether, this is my homage, as an artist, representing the aura and mystique of the sacred feminine through my sketched impressions of the vulva. The truth is unveiled and the mystery remains.

QUESTION: **Any final words to your avid viewers and readers?**

Artist JEGAL: Yes. Yes. The art of the vulva is a real power source of infinite energy. The vulva is the ultimate art. The art of the vulva! I am moved to great creative spurts of excitement as an artist in the creation and design of my paintings and drawings because of my ability to transmute feminine energies into the expressions of my works. It makes life fun every day, on any day. The love of women as true natural art is what I am most thankful for to God at all times. Thank you. Goodbye, until we meet again somewhere next time.

Acknowledgments

Thank you to Google, Wikipedia, and "The Book of The States" by Vincent Wilson, Jr. for general data in research on the various states.

Thank you to all those who have been directly or indirectly related in my pursuit of the ultimate art, 50 Shades of V, classic black-and-white. The anonymous posers hold a special place for me in my artistic heart and mind. Women are truly the most fascinating people. I am in awe!

I would also like to thank my book partner, Purple Whale Publishing, for their patience and dedication in making this book a reality.

Special thanks to Judi Davenport for help in bringing the final draft to book form. And also a special thanks to Lorie Lulick for the idea of the book cover design.

Finally, I dedicate this book to each of my secret anonymous posers and everyone who wonders as they peruse these pages—"Maybe I know that person . . ."

Love to All,
Artist JEGAL

Printed in the USA
CPSIA information can be obtained
at www.ICGtesting.com
LVHW060845250823
755873LV00003B/8

9 781733 624695